The Campus History Series

SAN FRANCISCO STATE
UNIVERSITY

The Campus History Series

SAN FRANCISCO STATE UNIVERSITY

MEREDITH ELIASSEN

ARCADIA
PUBLISHING

Copyright © 2007 by Meredith Eliassen
ISBN 978-0-7385-5566-9

Published by Arcadia Publishing
Charleston SC, Chicago IL, Portsmouth NH, San Francisco CA

Printed in the United States of America

Library of Congress Catalog Card Number: 2007928964

For all general information contact Arcadia Publishing at:
Telephone 843-853-2070
Fax 843-853-0044
E-mail sales@arcadiapublishing.com
For customer service and orders:
Toll-Free 1-888-313-2665

Visit us on the Internet at www.arcadiapublishing.com

*Dedicated to my teacher C. R. "Buzz" Anderson (1933–1993),
who taught students to knock down barriers to social justice
and truth*

CONTENTS

ACKNOWLEDGMENTS

This book was written to commemorate the best of San Francisco State: its students. During the early 1970s, the offices of student organizations were demolished without ample time for the organizations to clear their papers. Every effort was made to provide photographer credits, but in many cases names could not be found. This book would not have been completed without support from the following: the Special Collections and Archives staff of the J. Paul Leonard Library, including Cydney Corl Hill, Colomba Ghigliotti, Ryan Morley, and Susan Sherwood; Yasaman Mostoufi; and Media Access Center staff. This project is indebted to Holloway Historians, organized by Helene Whitson and Arthur Chandler. Additional images come from the San Francisco State University (SFSU) Photograph Archives, scrapbooks, student newspapers, and the SFSU News Bureau Collection in the SFSU Archives. Some photographs were provided by outside sources such as Gail McGowan, Sam Goldman, Robert L. Tognoli, and the *San Francisco Chronicle*. Special thanks go to Arcadia Publishing editor John Poultney for his calm strength when the road got rocky.

INTRODUCTION

From San Francisco State's inception, its history and destiny have been linked to the city of St. Francis: San Francisco. A committee of San Franciscans drafted a petition requesting that the California legislature establish a state normal school in 1862. Funding for a weekly trade school for elementary teachers in San Francisco was approved, thus establishing the first state-supported institution of higher learning in California. The Normal School was moved to San Jose in 1871, and San Francisco State Normal School was recreated by an act of the legislature on March 22, 1899. Its board of trustees appointed Frederic L. Burk founding president, and Burk chose *Experientia docet,* "Experience teaches," to be the Normal School's motto.

Burk promoted educational efficiency that motivated students. San Francisco State was established on the principle that teaching was a calling and fostered a community of teachers committed to academic excellence. San Francisco State's community-based curriculum dates back to the early 1900s, when California women gained the vote in state and local elections, exercising that power for the first time in 1912. Students entered San Francisco State's two-year program at age 15. All students attending the Normal School were required to take rigorous entrance exams testing math, literacy, and geography. This was one of the first such testing programs in the country. Although the Normal School was never considered an all-women's school, the first man was admitted in 1904 and the second in 1915. After the Panama Pacific Exposition in 1915, a portion of the fair grounds was offered to the state as a site for the Normal School but was not considered suitable.

The Normal School began a slow evolution from a vocational school for teachers to a liberal arts college after World War I. The California legislature established three-year programs at state teachers' colleges in 1921. The war broadened an interest in world affairs among faculty and students. San Francisco State faculty developed innovative programs that attracted the best pupils. Geography professor Anna Verona Dorris established a media collection to serve as visual instruction material for faculty and students; it later became the pioneering audio-visual center. Biology courses were first offered in 1924, with Prof. Edith Pickard advising students interested in medicine, dentistry, and pharmacy. Students first published a newspaper, the *Normal News*, in 1921, but no extant issues of this publication remain. The first issue of the *Vigilante*, a monthly student newspaper published by the Good English Club, appeared in November 1922.

After expanding its liberal arts curriculum, the school was renamed San Francisco State Teachers College in 1921. The Teachers College emerged as a leader in developing programs that served students from different socioeconomic backgrounds. In 1925, the Associated Students elected their first officers: Gladys Maxwell (president), Claranne Hubor (vice president), and Alice Hazelwood (secretary). Students graduated with the confidence that their education had prepared them to competently teach in any environment. The kindergarten department expanded into the

kindergarten primary department, and the Teachers College was authorized to award Bachelor of Arts degrees and teaching credentials in kindergarten, primary, and elementary education. Archibald Anderson became second president in 1924, serving until his death in 1927. On March 27, 1924, the cornerstone was laid for the gymnasium, beginning a 10-year building program. Mary Ward, San Francisco State alumna and dean of women, served as acting president for three months in the summer of 1927 before Alexander C. Roberts was appointed third president.

In 1930, the California legislature lengthened the three-year course programs at state teachers' colleges to four years as more men attended San Francisco State. The government department was established in 1931 to develop knowledge, analytical skills, and critical insight into the nature of political science. During the Great Depression, when one-third of the workforce was unemployed, students scrambled to pay for school—many were the first in their families to attend. The college served as a place where men and women could get a practical liberal arts education for a reasonable price.

From 1940 to 1959, San Francisco State made a major transition from a small, over-crowded campus in the center of San Francisco to a spacious property in the southwest corner of the city where programs could be greatly expanded. Issues of academic freedom arose when California passed the Levering Act (Assembly Bill 61) obligating public employees to sign a loyalty oath. State employees were required to sign the oath before November 2, 1950, or have their names removed from the payroll. On November 9, 1950, these seven San Francisco State faculty and two non-academic employees were fired for "gross unprofessional conduct": Leonard Pockman, John Beecher, Frank Rowe, Eason Monroe, Phiz Mezey, Herbert Bisnow, Jack Patten, Lucy Hancock, and Charlotte Howard. Later some of the professors were rehired.

Dr. Glenn S. Dumke became fifth president in 1957. Prior to publication of the *California Master Plan for Higher Education* in 1960, Christopher Jencks (London School of Economics) and David Riesman (Harvard University) conducted a study of San Francisco State College and a comparable college in Massachusetts. The Jencks/Riesman study was highly critical of San Francisco State and the California State College System. It characterized San Francisco State students as those who would not attend comparable colleges on the East Coast. "They are students whose parents would not subsidize a college education, and who in an Eastern high school would not have seen college as important, much less feasible." The Jencks/Riesman assessment of the academic climate at San Francisco State angered Dumke, who was looking for strategies to better structure higher learning statewide.

The Associated Students, under the aegis of the Experimental College (a student-organized college within San Francisco State), sponsored a controversial weekend event called "Whatever It Is . . . " in 1966. Experimental College leader Jim Nixon cautioned, "It would be a mistake to assume that an event like this will be of interest to a majority of the student body." The intent was to create a "spontaneous" weekend celebrating San Francisco counterculture. The San Francisco Mime Troupe, using its portable stage, performed on the Quad; and fugitive Ken Kesey's psychedelically painted bus parked in front of the Commons while the Grateful Dead performed. During this unadvertised stop, Kesey, flanked with bodyguards from the Hells Angels, performed an "acid test" in the studios of the campus radio station KRTG. The event aired to listeners in the Commons, in the Redwood Room, outside through speakers, and to the KRTG audience in the dormitories.

The Poetry Center, as a cornerstone in the Bay Area literary scene, made San Francisco State a place to address the fundamental nature of literature when controversies arose. After clerks at the Psychedelic Shop and City Lights Bookstore were arrested for selling Lenore Kandel's poetry volume *The Love Book*, considered to be obscene, San Francisco State faculty read *The Love Book* and Allen Ginsberg's *Howl* in the Gallery Lounge. A week later, five San Francisco State faculty members followed up with a discussion of the nature of literature that aired on KQED.

Following his involvement in *The Love Book* controversy, English professor Leonard Wolf conducted classes on the first floor of Happening House, located at 409 Clayton Street, during the spring 1967 semester. Happening House was conceived as a "university of the Haight-Ashbury," a

cooperative venture between San Francisco State and young people in the neighborhood. Wolf moved rugs, chairs, and his library of paperbacks into the pale blue Victorian that became a hub for encounter groups, gestalt therapy sessions, and classes on natural childcare, cooking, and candle making. Wolf argued that hippies had not dropped out of society, that indeed they were "thoughtful people—committed, concerned and active."

The Philipino American Collegiate Endeavor (PACE) was established in the spring of 1967 to promote cultural awareness. PACE remains one of the oldest continuously active organizations at San Francisco State for students of color. Work-study staff developed a pilot project to conduct community research, tutoring, and group work, while receiving college credit for participating in seminars. During the summer of 1967, staff members worked in the Economic Opportunity Council's Summer Youth Program to arrange jobs for high school students from the city's Tenderloin, South of Market Street, and Mission neighborhoods. For some disadvantaged students, this became an incentive to remain in high school and graduate so that they could attend San Francisco State. When counseling professor Stuart D. Loomis helped establish the Haight Ashbury Free Medical Clinic to address public health issues connected to the Summer of Love, San Francisco State students volunteered at the clinic to refer patients.

The Experimental College had given students a taste of a new kind of educational openness relevant in a changing world. In 1968, Pres. John Summerskill resigned and Robert Smith became eighth president. The first dormitory to become coeducational was Merced Residence Hall, later renamed Mary Park Hall, the only state university building honoring a staff person. Responding to the coeducational status, one female resident said, "This is so nifty, being surrounded by a couple of hundred men! Wowie!"

Meanwhile, the Experimental College had not fully addressed the issue of relevancy for all students. George Murray, a lecturer in the English department with connections to the Black Panthers (and implicated in an assault on *Golden Gater* editor James Vaszko on November 6, 1967), was assigned to non-teaching duties. On October 28, 1968, Murray entered the Commons allegedly urging students to arm themselves with guns (even though no proof has been found to substantiate this claim). Under pressure from the Chancellor's Office, President Smith suspended Murray.

Smith resigned in November 1968, and S. I. Hayakawa was named acting president. Hayakawa's first act as president was to close the campus. Between November 1968 and March 1969, minority students—San Francisco State students of African, Asian, and Latin American descent—organized as Third World in the longest student-faculty strike in the nation's history. The Black Students Union (BSU) made 10 demands related to relevancy, including the consolidation of black studies courses into a black studies department with equitable pay for full-time instructors and the approval to award a bachelor's degree. The BSU also wanted a black financial aid officer to be hired and Third World to have power to determine how that office would be administered. In addition, the group demanded that California State College trustees not be allowed to dissolve any black studies programs on or off the San Francisco State College campus. Students in the Third World Liberation Front also stipulated that a School of Ethnic Studies represent each particular ethnic group corresponding with black studies.

The campus reopened on December 2, 1968. According to the *Daily Gater* (December 3, 1983), the first major confrontation occurred when striking students parked a sound truck with amplifiers on the corner of Nineteenth and Holloway Avenues. This happened in defiance of Hayakawa's edict banning sound equipment without special permission. Hayakawa climbed onto the sound truck to disconnect the speakers surrounded by a crowd of 200 picketers chanting, "On strike—shut it down!" A student pulled his trademark Tam o' Shanter from his head. Hayakawa shoved back. A scuffle ensued, and Hayakawa grabbed a female student by the wrist. She screamed, and a fellow student struck him. Hayakawa later called in the Tactical Squad to arrest the students.

The strike proved to be part of a continuum of San Francisco State's evolution. It distilled a point of view within the thousands who were affected by it. The Educational Opportunity Program (EOP) would expand opportunities and access to higher education. On March 21, 1969, administrators and strikers reached an agreement, and the School of Ethnic Studies was established in the fall.

Student organizations were never given the unprecedented power over hiring that they had demanded. Indeed, the strike curtailed much of the more radical counterculture aspects of the Experimental College, but students garnered increased representation.

In the decades following the strike, San Francisco State has worked to create affordable access to quality education for all. Robert A. Corrigan became the 12th president in 1988. In the midst of the college's 90th anniversary celebration, the Loma Prieta earthquake rocked the Bay Area. Corrigan sought to develop San Francisco State as a national model for a public urban university. To achieve this goal, he revitalized the physical plant of the campus to provide the best educational technology for the information age while quietly shaping a park-like aesthetic landscape.

In 1990, the Americans with Disabilities Act mandated compliance for disability access in public institutions by January 26, 1992. Kirk MacGugan was appointed physical and environmental disability coordinator to implement the 503–504 sections of the Federal Rehabilitation Act regarding people with disabilities. He worked with Disabled Student Services to integrate disabled faculty, staff, and students at San Francisco State into the campus community. MacGugan asserted that integration was about "breaking away from the isolation of special buses, special rooms, and special dorms. We've got to keep reminding ourselves that 'separate but equal' is not equal." Today San Francisco Sate continues its mission of responding to growth and change in San Francisco and the Bay Area by promoting respect for academic excellence, freedom, and human diversity.

One

ORIGINS
1899–1939

San Francisco State's story began with a distinctly meager and crude building—a renovated high school on Powell Street beyond the top of the hill—not far from Clay Street. The Training School was housed in an old elementary school on loan from the city and situated a few blocks farther down on Powell near Chinatown. Children in the practice school came from Chinese or other immigrant families, creating a sense of energy, interest, and diversity. Dr. Percy Davidson of Stanford University, a respected scholar in the area of child development, noted that the Normal School's outward structure did not deter President Burk from creating an impressive vision for San Francisco State as an institution of higher learning grounded in and derived from active participation in community events and activities: "He was far more concerned with what went on inside a school than he was with its architecture or ornamental embellishment. Educational swank and impressiveness left him cold. I suspect he was rather proud of his ability to do an outstanding piece of work in humble surroundings."

The 1906 San Francisco earthquake and fire destroyed much of the city, including the original San Francisco State Normal School campus. Burk got the Normal School up and running within a few weeks and then acquired new land. Out of the turbulence, he lobbied Gov. George C. Pardee (1903–1907) to improve state textbooks. Relevant education would become the hallmark at San Francisco State. Burk believed that no subject should be taught unless its educational worth was proven. He drew both acclaim and criticism for the belief and implementation of his "individual instruction method." This model for teaching success was particularly effective in San Francisco, where students from diverse socioeconomic backgrounds benefited from curriculum that allowed students to learn at their own pace.

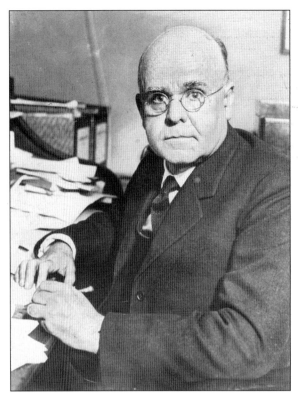

President Burk developed curriculum to create "dynamic energy" within students and promoted individualized instruction—building skill upon skill. Elasticity in the length of lessons ensured that no student proceeded until "a safe foundation" was laid. Burk wanted women to succeed to their full potential because teaching provided opportunities to obtain financial and intellectual independence. He recognized that strict curriculum in teachers' colleges could stifle creativity and deter individuality. Students, unused to discipline, might neglect to learn the prescribed task or lessons. Some did indeed become distraught, passé, or blasé and start to cause mischief. Burk remembered, "We undertook to remedy matters by announcing that thereafter no lessons would be prescribed, each would pursue his own lessons and proceed at his own rate. The result was electrifying."

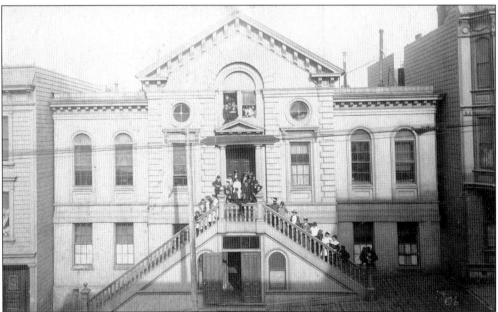

San Francisco State Normal School opened its doors to 31 young women on August 14, 1899. Its original location was Boy's High School on Powell Street near Clay Street. The outward structure of the Normal School was distinctly meager, but this did not deter President Burk, who was more concerned with what went on inside a school than with its outward architecture or ornamental embellishment. (Courtesy Gail McGowan.)

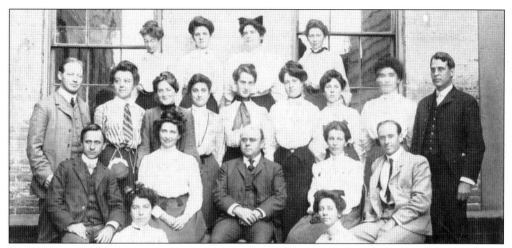

President Burk selected young faculty members to maintain his vision. Biology professor Effie B. McFadden (seated to the right of Burk) began teaching in 1900. The first chairwoman of the science department, she taught botany, zoology, and nature study. McFadden became the first emeritus professor from a California State College in 1938. Mathematics professor David Riis Jones (seated to the right of McFadden), first to head the mathematics department, also taught physiology.

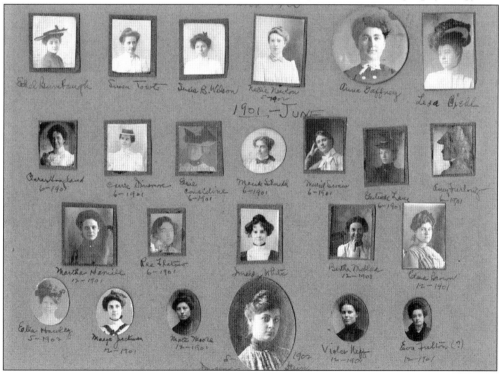

The earliest alumnae were motivated in their vocation of teaching. The class of June 1901 included Clara Hoagland, Carolyne Dinsmore, Elsie Considine, Maude Schendel, Muriel Swain, Gertrude Lane, Amy Furlong, Martha Hamill, Ray Flotow, Imelda White, Bertha Moblad, Clara Brown, Ella Hawley, Madge Jackman, Mate Moore, Imogene Stein, Violet Neff, and Eva Fulton. The class of December 1903 consisted of Ethel Bumbaugh, Susie M. Towt, Susie B. Wilson, Nellie Newton, Anne Gaffney, and Leda Piehl.

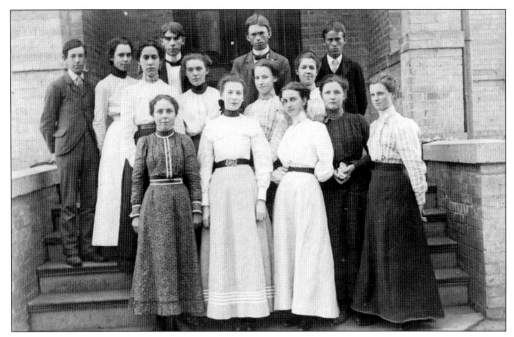

President Burk implemented the most rigorous entrance requirements of all the California State normal schools, with San Francisco State as the first normal school in the country to utilize entrance exams. Burk personally interviewed all applicants to determine if they had the proper dedication to teaching. San Francisco State Normal School's graduating class of 1904 is pictured in front of the Powell Street campus.

San Francisco State alumnae became pioneering educators. Clara Crumpton (class of 1901) was appointed to the Normal School faculty from 1905 to 1909 and then left to teach elementary schools in the San Francisco Bay Area, organizing the first public school in Piedmont. Crumpton returned to San Francisco State, serving as registrar from 1919 to 1943.

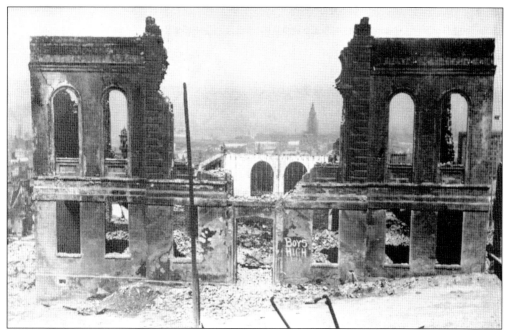

The 1906 earthquake and fire destroyed much of the city, including San Francisco State's first campus. The remains of the city hall spire can be seen through the ruins of the Normal School. Within weeks, President Burk ushered San Francisco State into session at the Grant School in Oakland. In the years that followed, it became a commuter campus with students traveling by ferry and then transferring to the Market streetcars to attend school.

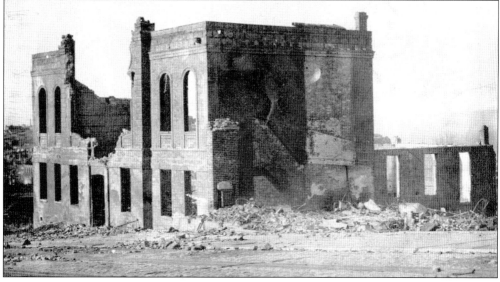

San Francisco State's Training School was the first public school to open after the earthquake. No summer vacation was taken to make up for time lost. Mary A. Ward, a freshman at San Francisco State, was among the students who had crossed San Francisco Bay by ferry to attend classes in temporary facilities at Grant School. After 11 weeks in Oakland, the Normal School reopened in a new location—a block located in the heart of San Francisco and bordered by Buchanan, Haight, Laguna, and Waller Streets.

The elementary department was established in 1913, one of the first to teach individual progress for children. San Francisco State's earliest seal was embellished with a lovely Art Nouveau design of California's golden poppy. The seal celebrated the Normal School's place in the heart of San Francisco before the Golden Gate Bridge existed. Minerva, the Roman goddess of wisdom, holds a torch of illumination high over the bay.

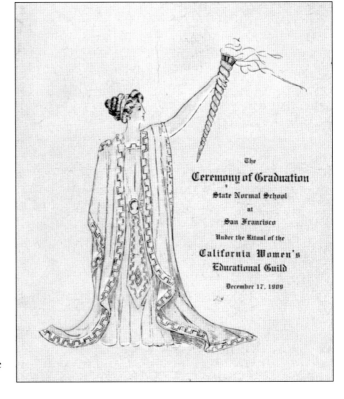

President Burk developed the Ritual of the Teachers' Guild Service in 1909 as the Normal School's commencement exercise. In this elaborate ceremony, performed annually for 20 years, white-clad students consecrated their commitment to teaching before entering the profession.

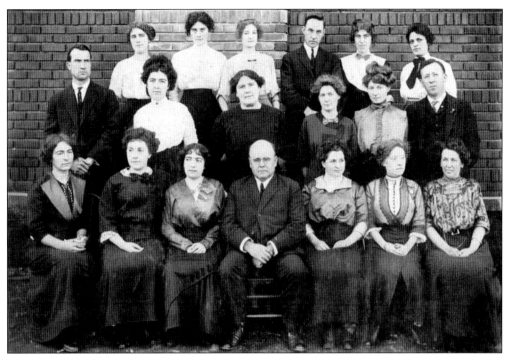

Mary A. Ward (second row, second from left), pictured with Normal School faculty in 1912, was San Francisco State's only dean of women, holding the office from 1916 until her retirement in 1951. Ward, who shaped campus life and created opportunities for all students, served as acting president for three months during the summer of 1927.

The Protestant Orphanage, converted into the library and the Training School, was gutted by fire on June 12, 1917. The Training School moved into the Waller Street wing of College Hall. It was established as an experimental school, organized to demonstrate and practice educational theory, procedures, and materials. It consisted of class levels from kindergarten through eighth grade.

President Burk had been involved with the kindergarten movement in California. Art, as a natural expression, was cultivated in kindergarten classes. First offered as a course at San Francisco State in 1903, art was considered an important skill in the Normal School's curriculum. The Department of Drawing and Art was expanded in 1923 to prepare students for professional careers related to the fine arts.

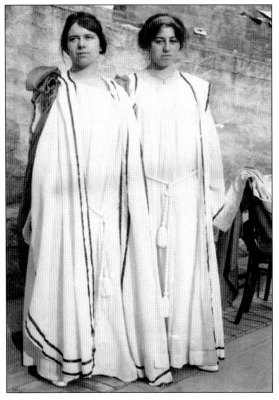

During the Ritual of the Teachers' Guild Service, undergraduates wore a sash and trim color that reflected the original school colors: green and gold. The undergraduate robe was green, and graduates wore a gold-colored trim. The school colors were changed in the 1920s to purple and gold, so the sash color became yellow for graduates and purple for postgraduates. Undergraduates did not wear a sash.

President Burk employed the best students in positions of responsibility at the Normal School. Florence Vance entered San Francisco State in 1908 and received her elementary credential in 1910. She was immediately appointed to the faculty, assisting the geography instructors with maps and teaching geography at the Training School. During the 1920s, Vance served as recorder and was promoted to college registrar, a position that she held from 1934 to 1954.

Home economics courses, dating to 1901, were renamed household arts in 1917. Prof. Alice Spelman established the home economics department in 1923 and introduced Delta Sigma Nu (the honor society for home economics) to San Francisco State in 1930. She carried a heavy teaching load that increased during World War I and II, when she taught special nutrition courses for student nurses in city hospitals.

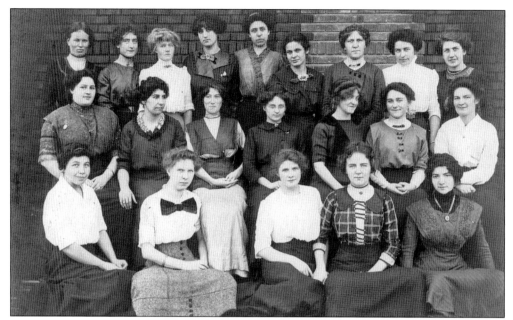

The Normal School set certain dress standards for students, as evidenced by this 1916 class photograph. Registrar Florence Vance stated that Burk "prohibited open neck attire and insisted on long sleeves and dresses down to the ankles." Codes of conduct and dress encouraged individuality by maintaining a middle ground between ultra-conservatism and ultra-radicalism, while hoping to accomplish these ends with economy.

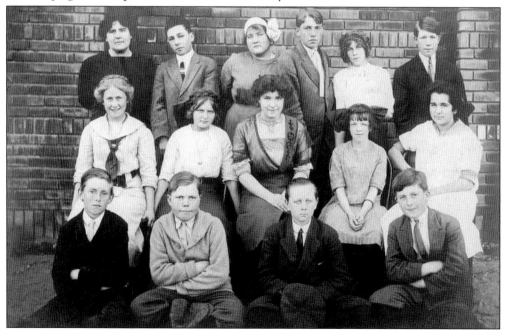

Training School assistant principal Eva Levy (third row, far left) poses with students in front of College Hall on the Buchanan Street campus in 1917. Student teachers attending the Normal School observed master teachers as part of their education curriculum. Under their supervision, they taught, produced instructional materials and lesson plans, and tested their outcomes.

Physical education courses were first offered in 1917. Women's physical education professor Florence Hale Stephenson was appointed in 1918. As department head, Stephenson supervised physical education activities in the Training School and assisted in coaching team games during the spring and fall sports seasons. Students enjoyed playing volleyball and ice-skating, while the swim team practiced at San Francisco's legendary Sutro Baths.

The nursing curriculum was initially designed to help registered nurses teach in schools. President Burk appointed Dr. Edna Loch Barney, considered one of the finest teachers at San Francisco State, to the role of college physician in 1919. Dr. Barney's clarity, directness, simplicity, and wry humor made her courses memorable. She instituted the first degree program for nurses at California State teachers' colleges.

Archibald B. Anderson served as president of San Francisco Teachers College from 1924 to 1927. Anderson had been a student at Santa Rosa High School where Frederic Burk was a principal. An apocryphal story asserts that Archibald Anderson's wife, distraught that he had remained acting president until shortly before his death, destroyed all of his papers connected to San Francisco State.

The first yearbook for San Francisco State was published in 1926. This edition of the *Franciscan* presented a time capsule of young ladies with bobbed hairstyles and one Asian American student, Alice Fong. Chinese Americans traditionally attended special segregated schools in San Francisco. Alice Fong Yu, the first Chinese American hired as a bilingual teacher in a San Francisco public school, graduated from San Francisco State in 1926.

Three members of San Francisco State's Glee Club pose in front of Anderson Hall. Considered one of the most active and progressive groups on campus, the Glee Club participated in a broadcast of "The Swallow," a cantata by Paul Bliss, on KGO Radio on October 17, 1926, and enjoyed a Chinese dinner at the Yuen Tung Lou followed by entertainment at the Chinese Social Center on March 7, 1927.

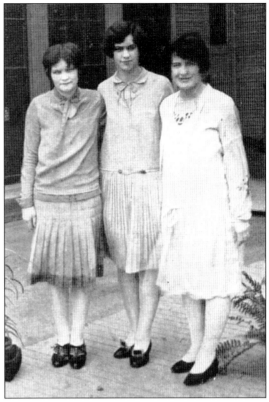

While the Ritual of the Teachers' Guild Service started as a simple event in the assembly hall of the old Normal School in 1913, the Greek Theater at the University of California–Berkeley had become the backdrop for the ceremony by 1929. The ritual included hundreds of students performing sacred incantations in symbolic formations embodying the life, work, and ideals of educational service.

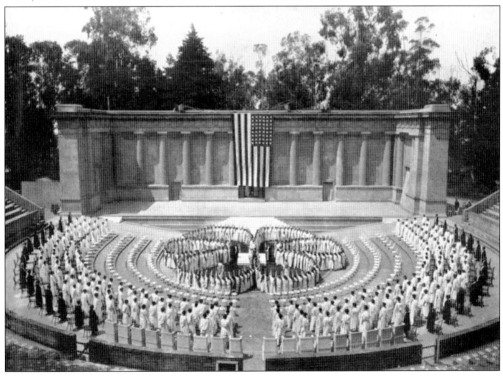

The theater arts department started as dramatic arts in the English department in 1922. The College Theater was established in the spring of 1925. Early thespians fondly remembered the old auditorium, with its squeaky stage and pillars obstructing views for those unlucky enough to get a middle-section seat. Here Alice Humphreys (left) and Dorothy Louder model costumes from *Kiss for Cinderella* by J. M. Barry, performed in January 1926.

San Francisco State gained its reputation as a fine teachers' college in the 1920s as its curriculum expanded to world issues. Vivian Walsh (class of 1930) was a typical student who studied education as well as music. She went on to become the first violinist in the college's string ensemble and the college's orchestra (see page 25 and 29.)

The architectural design of Anderson Hall featured the perfect symmetry of the Spanish arch reminiscent of bygone years. Through hazy afternoon sunlight, the campus grounds, according to the 1928 edition of the *Franciscan*, assumed "for a fleeting hour an ethereal vastness, a symphony of perspective."

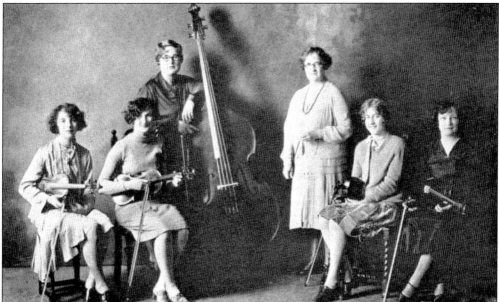

San Francisco State's string ensemble, established in November 1927, was part of an impressive music department dating to 1899 with a course called the pedagogy of music. Students could learn about music history and appreciation, choral technique and conducting, teaching school orchestras and bands, voice and ear training, and other special topics related to developing community music programs.

In November 1928, members of the Glee Club performed "The Flirting Song" for President Roberts. Prof. Eva Levy, a graduate of San Francisco State who helped to direct the annual Ritual of the Teachers' Guild Service for the graduation ceremony, established the Glee Club in 1920. It performed for special campus occasions.

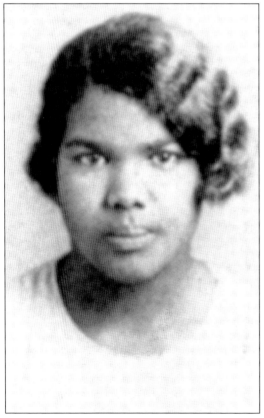

San Francisco State started modestly as a vocational school for teachers, but it welcomed students reflecting impressive diversity. Grace Hackett of Alameda was one of the earliest known African Americans to graduate from the college, in 1929. Hackett studied elementary education and taught at Allensworth School, located in a California black community in Tulare County, from 1931 to 1935.

Student Elizabeth Jones presents President Roberts with a spade used in the ground-breaking ceremony for the new Frederic Burk School on March 31, 1928. Under Roberts's tenure, the college acquired land near Lake Merced for a new campus, and San Francisco State shifted from a teacher training institution to a liberal arts college.

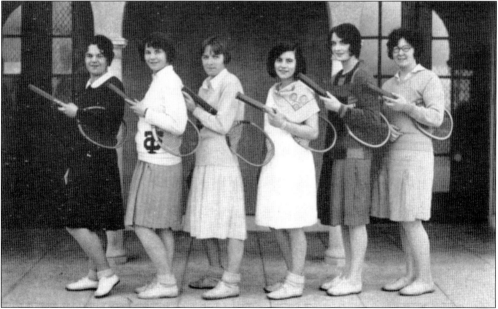

The Women's Athletic Association of San Francisco State Teachers College joined the Athletic Conference of the American College Women in the fall of 1928 as part of a national college movement to develop school spirit and maintain excellence in women's athletics. Women students enjoyed more athletic programs, including basketball, tennis, golf, ice-skating, and speedball.

THE CRAZY QUILT

In 1928, San Francisco State reached a new era with President Roberts at the helm. Student images from the class of 1928 have been stitched together to reflect the college's dynamic energy.

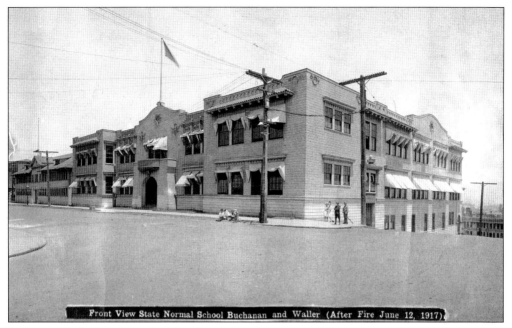

Front View State Normal School Buchanan and Waller (After Fire June 12, 1917)

Anderson Hall, the science building located on the corner of Buchanan and Haight Streets, was completed and dedicated in 1928. Students worked for neighborhood businesses that paid 35¢ per hour. With no existing dormitories, students boarded for $15 per month and light housework. An addition to Anderson Hall was erected in 1935.

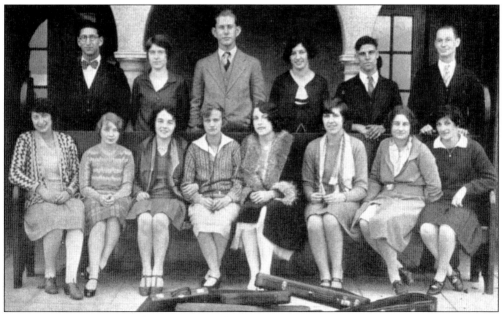

The college orchestra made its debut with the College Theater on October 3, 1928. Starting with four members, it grew to 29 by the following year. William Knuth, who established the music department, is credited with developing the concept of combining theater, music, art, and broadcasting into a single working unit known as the creative arts.

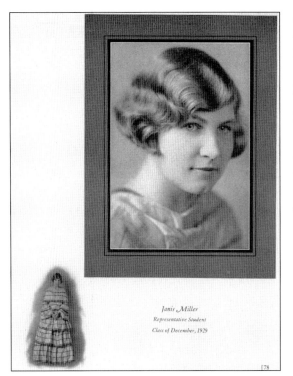

Janis Miller
Representative Student
Class of December, 1929

[78

The theme for the 1929 *Franciscan* yearbook was the State of Womankind. Janis Miller (class of December 1929) appears in period costume for Franciscan Day on February 14, 1929. The Great Depression deeply affected students at San Francisco State, many being the first in their families to attend college. The dean of women, Mary Ward, suggested in an article for the *Golden Gater* that students perform housekeeping to augment their income during the national crisis. Ward suggested a fair wage scale of 35¢ per hour for care of children and light housework such as preparing meals, cleaning floors, and ironing. She said, "In these alleged depressing times many women students are in need of part-time work to supplement the small allowances provided by their fathers."

President Roberts and student Kathleen O'Sullivan light a fire to burn old shacks on the Buchanan Street campus, including the cafeteria, home economics building, and lunchroom, in October 1929. Located on less than an acre of land, the campus had already become a firetrap. Afterward students searched for souvenirs in the rubble. Annex buildings were constructed to accommodate the overflow of students in 1934.

This night view of San Francisco State during the 1930s presents the beauty of the old campus. In 1930, Dean Mary Ward asserted, "Well-equipped buildings, fine faculty, rich curricula are the framework but not the cornerstone upon which the greatness of a college rests. College leadership is dependent upon the professional skill, personal character, and ideals of its graduates."

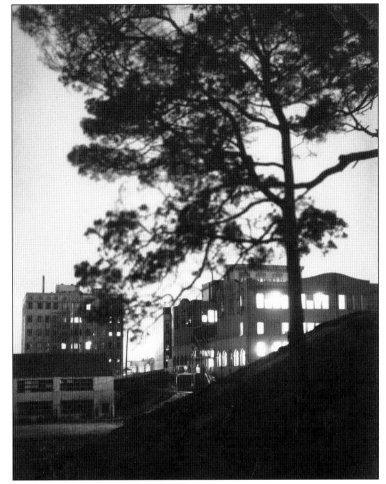

The Honors Club was established in February 1932 for juniors who had attained honor status, thus motivating lower classmen to strive for higher scholastic attainments. Of its 25 charter members, Wilma Orton, Elizabeth Hall, chairwoman Dorothy Dalton, and Ethel Rosen were photographed from left to right for the 1932 *Franciscan*.

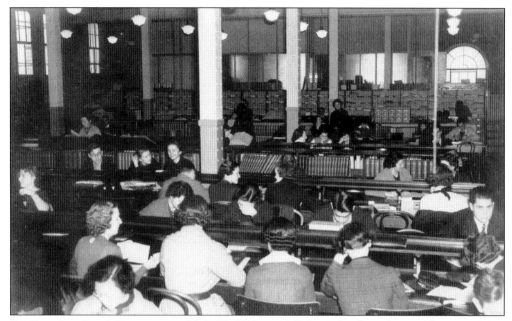

San Francisco State's library opened July 21, 1901, specializing in books and pamphlets pertaining strictly to education, but was destroyed in the earthquake and fire on April 18, 1906. During subsequent fires on June 12, 1917, and February 21, 1939, the library sustained heavy losses. In the 1920s, students paid a $1 fee used to purchase new books and additional copies of heavily used materials.

Dance classes were first offered in 1917 as part of physical education training. The Kappa Delta Tau sorority was established in the early 1930s to further the study of dance on campus. Elsie and Margaret Schulte performed in a dance, "Revery," drama at the Community Playhouse of the Western Women's Club, located on the corner of Sutter and Mason Streets, on March 30, 1932. Their performance was accompanied with music, rhythms, and artistic lighting effects.

Music professor Eileen McCall organized the Madrigal Singers, the first group on the West Coast devoted to studying English madrigals—contrapuntal folk songs written for mixed voices and performed a cappella—in the spring of 1931. Pictured from left to right are (first row) Mary Richmond, Alice Madden, Eleanor Quandt, Eileen McCall, Lorraine Walsh, Lavanda Hill, and Barbara Wuersching; (second row) Aldo Arnoson, Chester Beck, James Robinson, Richard Coughlan, Albin Berstrom, and Melven Kernan.

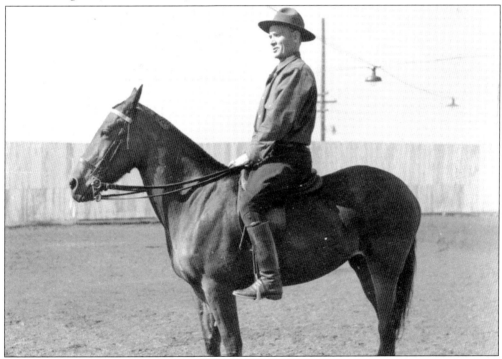

David Cox, pictured on horseback, was the first head coach and director of men's athletics at San Francisco State beginning in 1930. Coach Cox quickly formed two basketball teams, a respectable track squad, a successful swim team, and a football team. Men's team athletics commenced after four weeks of practice with a basketball game against the Salvation Army on February 28, 1930. San Francisco State won. Coeducational physical education classes started in 1931 and intercollegiate athletics in 1937.

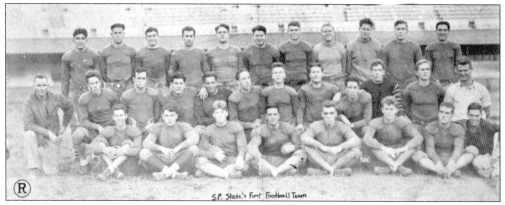

The college's first football team is seen in 1931. Members, listed by last name, were as follows, from left to right: (first row) Alderman, Sampson, Peterson, Rudd, Garden, Crester, Perrine, and Dumesnile; (second row) Coach Cox, McDonald, Bell, Krieger, Saadullah, Hull, Aubel, Treager, Furst, Parker, Christensen, and Gschwend; (third row) Sampson, Nolan, Donnell, Kaufman, Drysdale, Goldman, Dierke, Nickerson, Woodworth, R. Peterson, and Bragg. (Courtesy Sam Goldman.)

The Block S Society was formed in the fall of 1931, awarding 17 students with the Block S. A tradition sponsored by the society, the Frosh Brawl matched freshmen against sophomores for class pride commencing in January 1932.

The earliest known search for a San Francisco State mascot began in 1921. Nothing was decided until 1931, when the college newspaper challenged students to choose. The gator symbolized the college's tenacity and its connection to the "City by the Golden Gate." Each year, two female students were selected as alligator mascots. Once selected, the students remained anonymous.

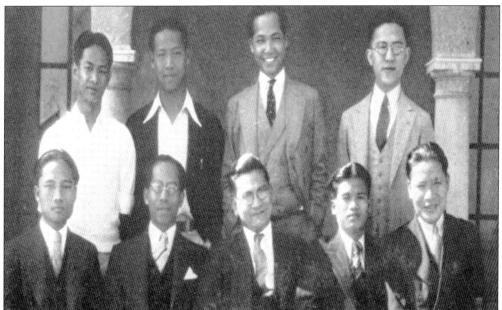

San Francisco State drew wide acclaim during the 1930s when it offered the first courses in peace studies. As Asian American enrollment increased, Chinese, Japanese, Korean, and Filipino students organized an Oriental Club in 1931 to foster goodwill. Olive Thompson Cowell, who taught international relations from 1919 to 1955, established the Department of International Relations in 1933.

Students participated in special sessions at Camp Cazadero in Sonoma County during the 1930s. Similar extended learning sessions date to 1913, when afternoon courses aimed to help students who wanted to focus on specific topics. In 1915, the Normal School offered continuous sessions, only breaking for Christmas, New Year's Day, Independence Day, and Thanksgiving.

Summer session was first implemented in 1922. From 1928 to 1935, dean of women Mary Ward directed San Francisco State's summer program, which grew into the largest in California. She was the only woman in the country to direct a state summer school program with enrollment over 1,100. The extension division was created in 1929 and has continued, except for a break during World War II because of limited resources.

Audience eyes followed models on the catwalk during Bib 'n' Tucker's fashion show in 1941. Bib 'n' Tucker, a popular social sorority, was established in 1931 to create interest in campus fashions. Fashion shows, dances, teas, and other social functions raised money for Bib 'n' Tucker's annual Christmas party, at which underprivileged children received gifts. The sorority remained active until the late 1960s.

San Francisco State students flourished in the beautiful and changing landscape of the city. The Women's Athletic Association introduced horseback riding as a new campus sport in August 1931. Students gathered at the San Francisco Riding School to canter through Golden Gate Park and along Ocean Beach on Saturday mornings.

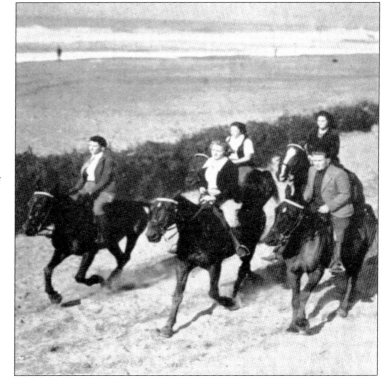

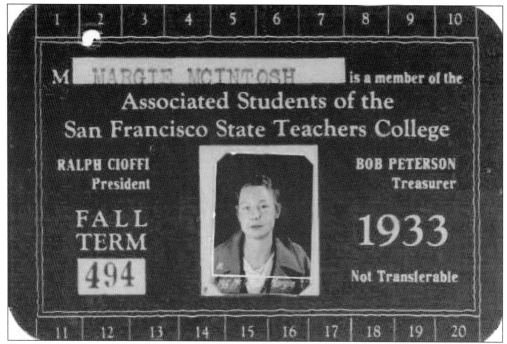

Student Margie McIntosh studied education before pursuing a long and productive teaching career. Once Prohibition ended in 1933, many female students chose beer on their first visits to public bars. In addition, the *Golden Gater* student newspaper was filled with editorials debating whether women should be allowed to smoke in public places on campus. Today San Francisco State is smoke free. (Courtesy Margaret McIntosh Curia estate.)

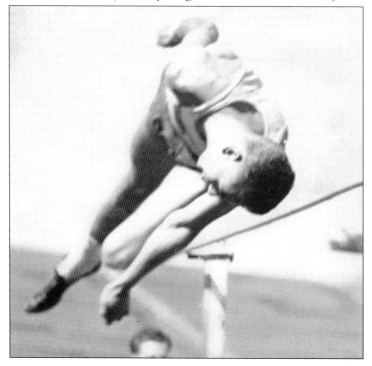

Runar Stone, San Francisco State's ace point-getter on track squads in 1935 and 1936, was the college's great hope to bring home gold at the 1936 Olympic Games. Nicknamed "Kichy Koo," "Finn," and "Ru," Stone was a champion decathlon athlete, one of the three best in California in his day. In 1936, he received two Block S awards—one for basketball and one for track.

The 1938 yell leader, Vernon Oulette practiced his moves in the courtyard on the Buchanan Street campus. Reflecting gender roles, the 1934 student handbook required that women hold the student offices of vice-president and secretary while men hold the offices of president, treasurer, athletic manager, and yell leader.

San Francisco State supported Runar Stone by raising funds for him to travel to the Olympic tryouts. Stone's best events were the high jump and high hurdle. Prior to the tryouts in Milwaukee, Stone suffered an injury and finished fifth in the finals for decathlon. After he graduated from San Francisco State in 1940, he served as the supervisor of building and trade work on campus until 1962.

Daryl "Hoppy" Hopkins makes his move past Bobby Kelenhoffer in old Roberts Stadium in 1937. Hopkins, who started on the football team, was acclaimed as one of the college's finest halfbacks but was forced to cease gridiron play when he received a dangerous leg injury. After rehabilitation, Hopkins devoted himself exclusively to track.

Social science professor Lawrence Kinnaird organized student leaders in 1936 to start planning for a student union where college organizations could meet. Students eagerly supported the idea of purchasing or building such a place. After much discussion, students and faculty decided to set aside a portion of student fees each semester and allow these funds to accrue.

Student body comptroller Leo Nee (right) clears the hurdle on President's Day in 1937. Nee came to San Francisco State in February 1932 to take charge of all student body finances. President's Day, March 22, commemorated the day in 1899 when the California legislature passed the bill establishing San Francisco State Normal School. Campus culture became lighthearted when President Roberts encouraged traditional campus activities.

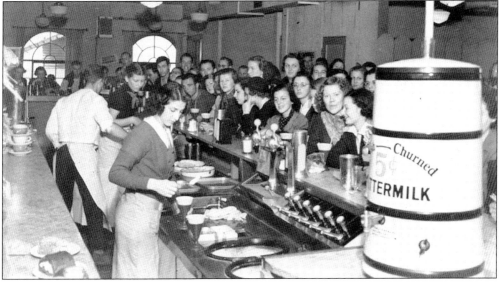

Students gathered in the College Hall Café in 1939, a pivotal year in a decade when the ratio of women to men shifted from 23 to 1 to approximately 2 to 1. During the early years at the Buchannan Street campus, there was no lunchroom, so students brought sandwiches or purchased hot meals in the neighborhood. Alice Spelman set up the first cafeteria in the 1930s that was later operated by the Associated Students.

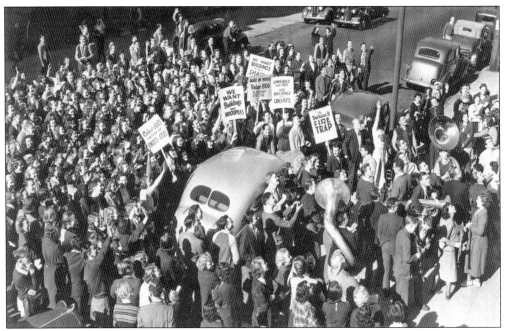

San Francisco State garnered a national reputation for student activism during the 1960s, but students have collectively shaped its values over the years. In 1938, students rallied for a new campus when the old wood structures of the Buchanan Street campus created dangerously crowded conditions.

Students cleaned up after a fire in the *Golden Gater* office in 1939. English professor Blanche Ellsworth taught journalism and served as advisor to the yearbook and student newspapers. Despite the close community at San Francisco State, space constraints affected the college library, along with the science, art, music, and physical education departments.

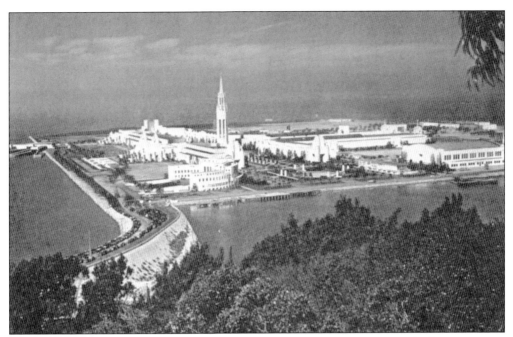

In 1939, students participated in the Golden Gate International Exposition. The fair committee invited a handful of students from Bay Area campuses to build up the mud island that became Treasure Island. Clifford Worth and his girlfriend, Dawn, who later married, were among the students transported to the island in a Crowley tugboat.

Francis Kelleher was chosen queen of Treasure Island for San Francisco State Day on May 6, 1939. During the festivities, the college received attention for its madrigal singers, a cappella choir, string quartet, and two student pianists. San Francisco State received plants from the event for the Lake Merced campus. Legend states that some remain planted adjacent to the gymnasium.

The journalism fraternity Alpha Phi Gamma began producing the Chickens' Ball in 1939. This annual event, continuing into the 1940s, raised funds for the Mary Louise Kleinecke Memorial Scholarship, given to an outstanding high school student planning to attend San Francisco State. Professor Kleinecke taught English from 1925 to 1939. Here Bob Sweeney (seated with the top hat) and George Fennemen get cozy as emcees during the 1940 Chickens' Ball.

San Francisco State's sorority sisters socialized and developed lifelong friendships, as evidenced by this Alpha Omega pajama party in 1940. The service sorority, established in 1939, participated in the Chickens' Ball to raise money for scholarships and student loans.

Maxine Albro, seen working on her mosaic for Anderson Hall, was employed by the Works Progress Administration to install the first mosaic carried to completion through every process in California. The mosaic was comprised of a palette of 29 different marbles depicting a boy with a book and a girl with a friendly squirrel sitting amongst indigenous California animals and plants.

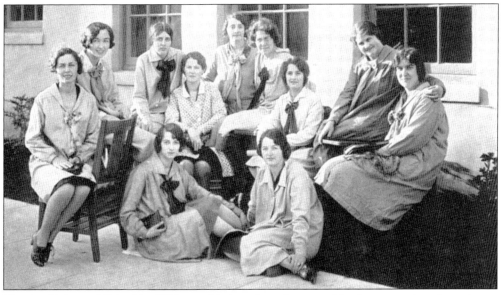

The Art Club, established in 1925, provided students interested in the arts and crafts a chance to perform extra work in their chosen fields. Students adopted the craft shop for their studios. Also known as the Brush and Palette Club, the group met on Tuesday afternoons to visit exhibits in the city.

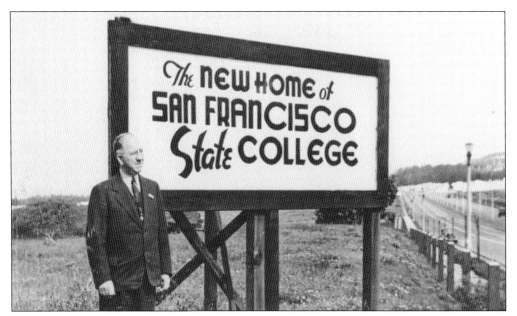

President Roberts posed next to the sign marking the college's future home after he and student body president Clifford Worth tramped around the Lake Merced site. Roberts, a man of great trust, allowed Worth to negotiate with the legislature to fund the purchase of land. After Worth graduated, he worked for Western Pacific Railroad but continued to lobby for land for a new campus.

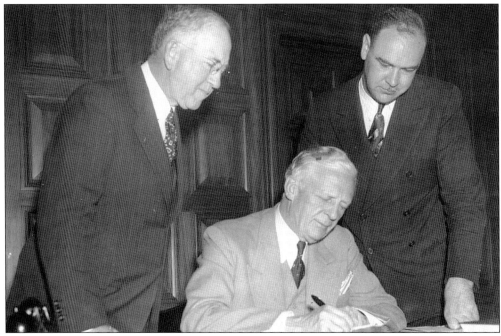

Gov. Culbert L. Olsen signed a bill ordering acquisition of new campus lands on July 15, 1939. President Roberts (left) and Sen. Jack Shelley witnessed this commitment of $1.5 million to purchase 65 acres of land from the City of San Francisco. The property acquired, west of 19th Avenue, was a marshy, sandy, and barren plot of land crossed by a large gully and creek that emptied into Lake Merced.

A ground-breaking ceremony for the Lake Merced campus was held in November 1939. Over 1,000 students attended the event despite rainy weather. The band and a cappella choir entertained the group while President Roberts (center) turned the first shovel of earth. The soil was placed in an earthenware vase and preserved for the college as Roberts, Senator Shelley (right), student body officers, and department of education officials watched.

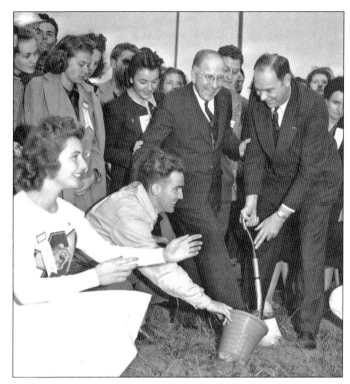

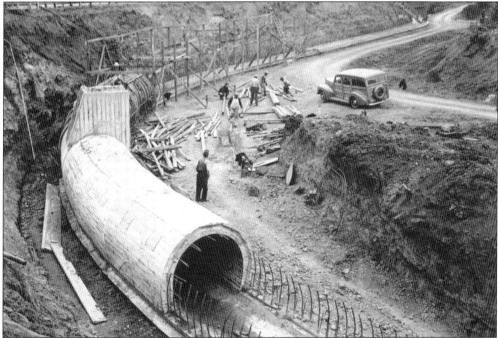

Developing the property required a feat of engineering. On April 1, 1940, some 150 laborers began construction of temporary buildings at the Lake Merced campus location. A system of pipes was laid, routing the gorge stream underground to discharge into the northeast arm of Lake Merced. The surrounding land was terraced into three level areas descending westward.

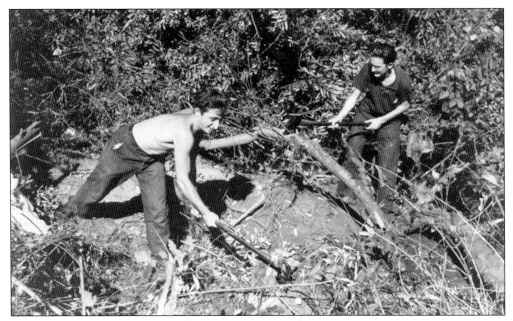

The swampy gorge filled with willow trees was cleared. San Francisco State ran a junior WPA program funded under the National Youth Administration, and in February 1940, students earned 25¢ per hour to cut down all of the trees. Freshman Paul Scholten (right) chopped the first tree with another student.

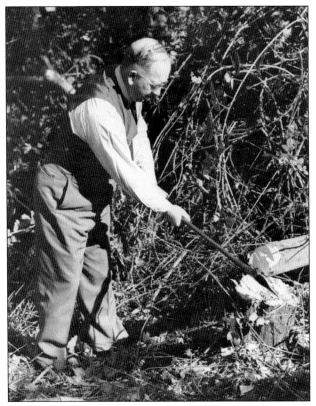

President Roberts came along later and had his photograph taken holding the ax. Landscaping to level and fill the stream canyon commenced in the northern portion of the property. All of the native vegetation was cleared. During World War II, the campus community supported the war by planting victory gardens in backyards and vacant lots. The Lake Merced campus included a nursery garden with lettuce, carrots, and chard.

Two

CREATING A RELEVANT NATIONAL MODEL FOR GENERAL EDUCATION 1940–1959

J. Paul Leonard was appointed fourth president toward the end of World War II. Leonard exploited opportunities created by the Servicemen's Readjustment Act of 1944 that provided educational grants to position San Francisco State as a premiere educational institution in the Bay Area. Struggling to maintain the school's pure dedication to academic excellence, he mobilized faculty to tie curriculum "to the life and interests of the Bay Area." Leonard saw an opportunity to take "a college with a creditable history—remake its instructional program to serve an ever-widening group of Bay Area young people, tie it closely to the life and interests of the Bay Area, and build an entirely new campus."

Mature students attending San Francisco State under the GI Bill demanded relevancy in education. Increased enrollment and diversity forced the college to shed its pristine teachers' college image to develop pragmatic community-based programs. Leonard, Associated Students president Izzy Pivnik (class of 1946), and hundreds San Francisco State students protested city hall's support of the Stoneson brothers' bid for land slated for a new campus near Lake Merced. The college prevailed, obtaining additional land for the new campus. In 1949, San Francisco State College was granted authority to issue master's degrees.

Leonard presided over the dedication of the Lake Merced campus on October 16, 1954. He worked with faculty to revise the college's approach to education and developed a general education program encompassing training in writing, speech, and reading and courses in social and civic understanding, the study of life values, and the world at work. Social science programs flourished at this time. San Francisco State College also coordinated a variety of work-study experiences to integrate into professional programs that would be adapted during the dramatic social changes of the 1960s.

In 1953, the school relocated to the new state-of-the-art campus at Lake Merced while still reaching deep into San Francisco's rich literary and artistic communities. English professor Ruth Witt-Diamant, with the support of poet Dylan Thomas and a $100 donation from W. H. Auden (half of his honorarium for giving the speech dedicating the campus), opened the Poetry Center, which created a West Coast headquarters for studying the work of Bay Area poets. Mark Linenthal and Jack Spicer offered courses that made poetry relevant on campus and in the community.

When the United States became involved with World War II, construction of the Lake Merced campus was stalled because of supply shortages. In 1941, the earliest structure, a small shack, was built next to the track and adjacent to Cox Stadium. The gymnasium was constructed in 1951, followed by the library. The business, science, administration, and arts and industry buildings were competed in 1953.

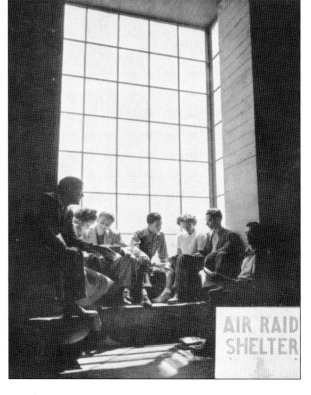

Students congregate by the windows in College Hall. In the foreground, a sign points the way to an air raid shelter in the basement. San Francisco State students looked toward the future even as the Buchanan Street campus stagnated during World War II. The Stoneson brothers, hoping to develop a property near Lake Merced, competed with San Francisco State to obtain land.

Dean of women Mary Ward relaxes with students in the science court before attending commencement exercises at the War Memorial Opera House in 1941. During the war, San Francisco State women moved into good teaching jobs. When it ended, more service veterans entered teaching and school administration. The college was called a "teacher mill" when it accommodated this new influx of students.

Yell leader Ivor Calloway poses with his assistants Gordon Mailloux and Al Maybe. The "State Victory Song" lyrics are as follows: "Golden tide is rising, / We're out to meet the foe. / Fighting ever on to / Victory for San Francisco. / 'Neath our golden banner / We'll win today for State. / Our colors o'er us—they go / Before us. / We're coming through the / Golden Gate."

Under the direction of Edwin C. Kruth, the college's bands became recognized as among the finest in the country. Kruth was known as an authority on woodwind instruments and a respected performer of the clarinet. During his tenure, the instrumental music department grew to be one of the largest music programs in the western United States.

San Francisco State student John Kikuchi was one of 19 Japanese American students interned during World War II. Kikuchi (first row, left), with San Francisco State's 1942 boxing team, was denied Block S recognition. He eventually received the award from Pres. Robert A. Corrigan. Today the Garden of Remembrance, dedicated on April 19, 2002, honors the Japanese students interned.

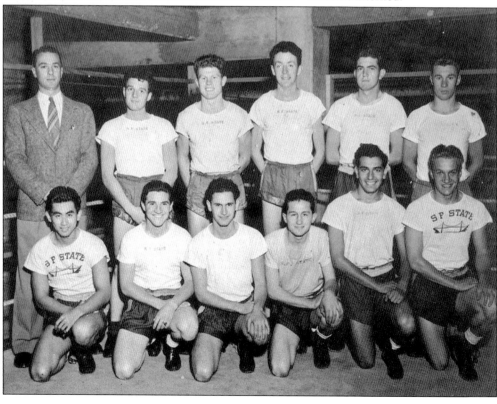

Audrey Steward seemingly flies over her classmates in a tumbling exercise performed in the science court. The college had a medium-sized gymnasium, where men's and women's classes alternated, was not large enough to support growing enrollment. Men crossed Market Street to attend the Salvation Army's gymnasium on Valencia Street or jogged to smaller gyms located at the First Baptist Church and Westminster Church. Women used the gym at the Emanu-El Sisterhood, 300 Page Street.

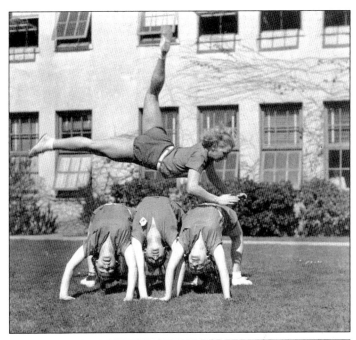

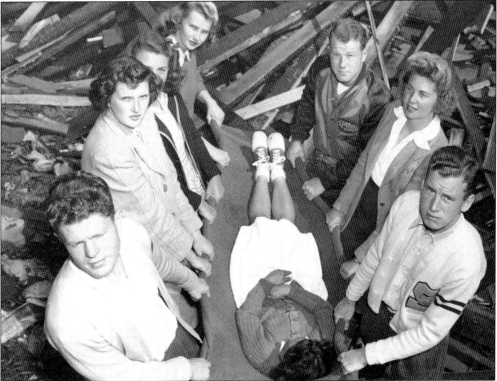

San Francisco State students participated in an emergency rescue drill during World War II. While land for a new campus was acquired in 1939, money was scarce for new building projects. In the absence of a good gymnasium on the old campus, the first goal on the Lake Merced site included a sports stadium and a physical education building.

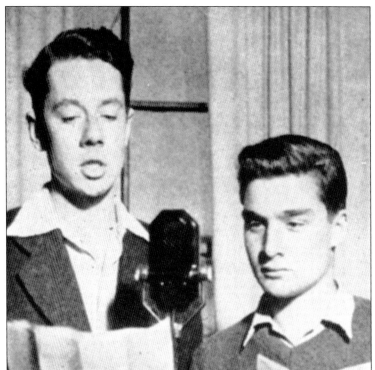

Students Bill Roddy and Pierre Salinger (right) delivered the news on the radio in 1942, when the speech, drama, and radio department was established. The broadcasting department, formed in 1969, prepared students entering the modern media of electronic communications.

During World Wars I and II, students balanced work and school with civic wartime efforts. The Red Cross organized on campus in 1943. Under the supervision of President Robert's wife, Emily (second from right), the San Francisco State chapter of the Red Cross opened its doors every Tuesday and Friday from 10:00 a.m. to 4:00 p.m., providing a spot where students, faculty, and parents could gather to sew and make gifts for servicemen and women.

When male enrollment diminished during World War II, women carried on tasks as they had when San Francisco State was still a normal school. The 1943 class officers included (from left to right) Mary Lewis (secretary), Paul Scholten (president), and Jean Evans (vice-president). Members of the class of 1943 had been paid by the National Youth Authority to clear the land for the new campus at Lake Merced during their first weeks of spring semester in 1939. Scholten went on to become director of women's services at Student Health Services.

San Francisco State instructors Clem Kennedy (left) and Ross Peterson pose with the percussion class from the 1943 Music Workshop. Music professor William Knuth established the summer Music Workshop in 1938 to benefit San Francisco junior and senior high school students. Sponsored by the Music Federation and staffed by San Francisco State students, this program provided quality music training in the city with expert teachers and conductors for a nominal fee.

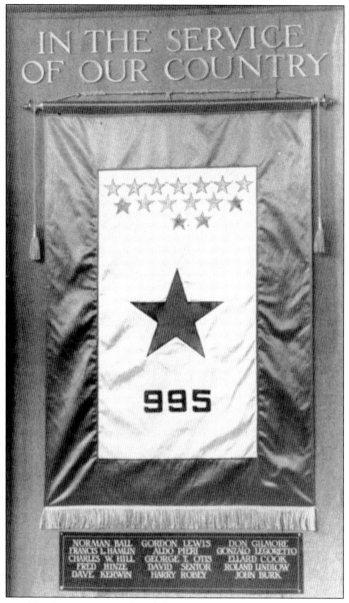

A banner, presented by the Parent Faculty Club, hung in College Hall to remember the students who served during World War II. Gold stars replaced service stars to honor those who died in battle: John Aristo (class of 1945), navy; Norman Ball (class of 1938), navy; David Braga (class of 1945), army air corps; John Bottscher (class of 1936), army; John Burk (class of 1942), army; Thomas Clark (class of 1944), army; Francis Cook (class of 1941); Donald Gilmore (class of 1944), army; Francis Hamlin (class of 1942), navy; Ludwig Hertz (biology professor), army; Charles Hill (class of 1941), army; Fred Hinze (class of 1943), army air corps; John Horner (class of 1942), army; Dave Kerwin (class of 1940), army; Gonzalo Legorreto (class of 1941), army; Gordon Lewis (class of 1941), army air corps; Robert Lindlow (class of 1940); Leo Morgan (withdrew January 30, 1943), army; George Otis (class of 1944,), army; Joseph Pieri (class of 1939), army air corps; Harry Robey (class of 1939), army; David Senter (class of 1943), army; and August Venturi (class of 1941), army.

In August 1945, J. Paul Leonard became the fifth president of San Francisco State. Leonard helped to advance the college in its evolution from a small campus to an urban university and restructured its organization from divisions to schools. Recognized as San Francisco State's "Builder President," trustees of the California State University and Colleges resolved to name the university library the J. Paul Leonard Library on May 26, 1976.

Students dash to class through the Haight Street entrance to Anderson Hall. Under President Leonard's direction, faculty organized a series of retreats at Asilomar in 1946 to develop a general education plan. This created a cohesive model for general education that drew nationwide praise for quality instruction that continues to this day.

Music Alley came alive with music day and night as students practiced everything from classical to the latest jazz. One of the greats to emerge from Music Alley was Cyrus "Cy" Trobbe (class of 1945), who taught at San Francisco State. This prominent English-born violinist played gigs at KPO during its pioneering days in the 1920s and served as the Curran Theater's musical director from 1934 to 1976.

Art professor John Gutmann, who photographed these students in his poster design class in 1941, started at San Francisco State in 1938. In 1946, he founded the creative photography program, the first curriculum in the country to teach photography as a fine art. He also established the college's Art Movies series, which explored the Bay Area's experimental film industry between 1949 and 1963.

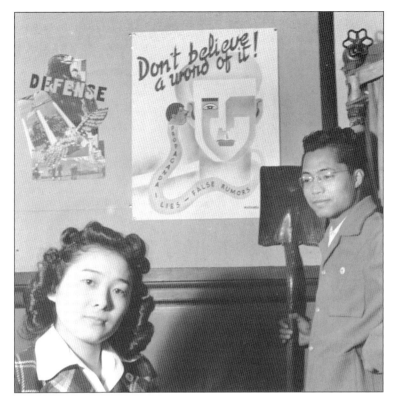

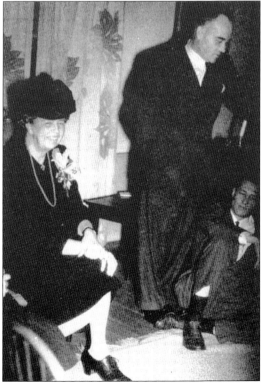

In 1947, the Associated Students incorporated with the goal of formally executing student business activities. A hush filled the air as former first lady Eleanor Roosevelt entered the living room at President Leonard's home on March 8, 1947. Roosevelt's visit for Leonard's Fireside Chat, during which she talked about her work for the Commission on Human Rights, was a complete surprise for the San Francisco State students in attendance.

Tuition cost $6.50 in 1947. Students also paid a $4 materials and services fee and a $10 college activities and health fee. With 3,400 students enrolled and classroom space for only 1,500, five hundred applicants were turned away during fall 1947. There were no classes available for courses requiring heavy equipment, no room in science labs and in morning lecture classes, and not enough housing for married students.

George Fennemen (far right) participates in Sigma Pi Sigma pledging rituals on Ocean Beach in 1946. Bud Werner, Edward Barry, and Jack McGann are pledges trying to make the grade. Established in May 1938, Sigma Pi Sigma was a men's service fraternity that aimed to boost school spirit. It curtailed activities from 1941 to 1946 because of World War II.

Men returning from war service needed to reenter the civilian work force quickly, and the GI Bill paid $500 in tuition and expenses for veterans seeking higher education. San Francisco State awarded course credit for military service, for courses taken at the Armed Forces Institute, and for passing GED tests. In February 1947, married veterans migrated to the 84-unit Vets Village, located on the Lake Merced campus.

The wrestling team worked out daily in the "Rat Hole," an unfinished cellar below the Frederic Burk School's foundation. The Rat Hole was known for its cobwebs, stale air, and lack of windows. Pictured from left to right are the following: (first row) John Holden, Bob Anderson, Stu Marcereau, and Hal McJilton; (second row) coach Bert Gustafson, Wilber Carlson, Cliff Gray, and Paul Caintic.

Chico State's catcher tags Tom Gaffney out at the plate during an attempted squeeze play. With only 10 showers in a cement alcove on the old campus, students took turns showering during the last 10 minutes of each gym period. Those in field sports and archery traveled by shuttle bus to the new Lake Merced campus, making the round trip and participating in class within the allotted exercise hour.

In 1938, San Francisco State introduced international programs that continued until World War II. The California State International Program (study abroad) was established in 1968. Mary Ward, the dean of women, wearing a hat, is shown with (from left to right) Kishori Mohan (India), Haen-Luen Ma (China), Bill Friedaman (United States), Rebecca Isreal (Greece), Bernardino Castro (Philippines), and Jose Heyliger (Nicaragua) in 1950.

Dave McElhatton, one of the earliest students to graduate from the broadcasting department, prepares for a broadcast by the Radio Guild. Two weeks after graduation, McElhatton joined KCBS and found success with his all-night radio show "Music 'Til Dawn." His KCBS program "Viewpoint" was the Bay Area's first telephone talk show. He then worked for KPIX (CBS) in 1977, becoming a top anchor in San Francisco.

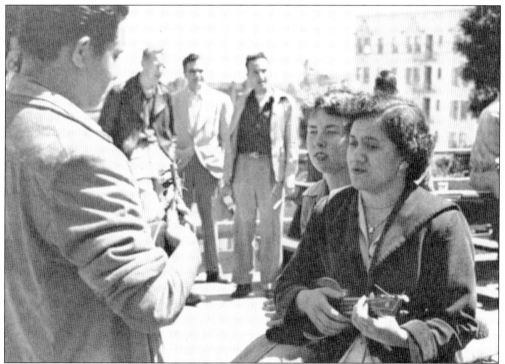

Ukuleles became popular on campus during the early 1950s when the Hawaiian Club celebrated Polynesian culture. Members of the New York counterculture Beat movement began migrating West to San Francisco's North Beach neighborhood because of inexpensive rents, making the city a new center for literary and intellectual creativity.

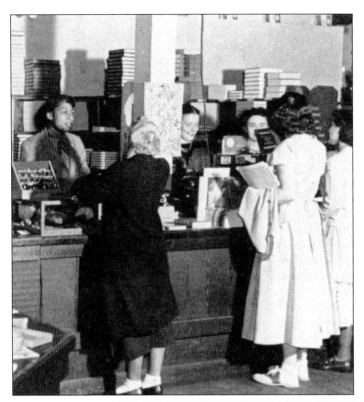

Sally Wilde was appointed manager of the bookstore in 1936, when it was located on upper Market Street. She held the position through a period of immense growth while it moved under the jurisdiction of the Associated Students. Wilde expanded the bookstore at its headquarters on the new campus, instituting a self-service system in which textbooks were arranged alphabetically by course.

The Rock was the only campus-connected housing serving the Buchanan Street campus for men who were not veterans. Residents did all their own cooking and cleaning. San Francisco State owned the house, located at 2255 Mariposa Street, where 25 to 30 men lived under the supervision of college student employee Herb Colton and his wife.

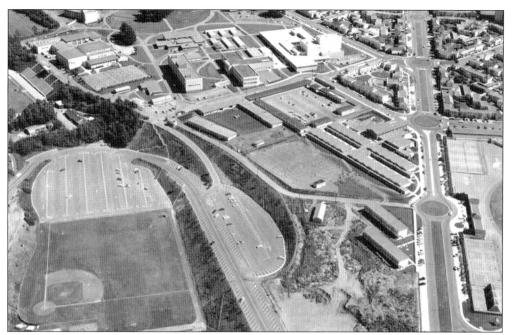

This 1953 aerial view of the new Lake Merced campus shows a fresh landscape for learning. The Stoneson brothers began work on their ambitious Stonestown project, which would become the fourth largest shopping center in the country. On November 16, 1952, America's Smartest Center was launched with great fanfare. In the mid-1980s, Stonestown underwent a renovation to enclose the buildings and was renamed Stonestown Galleria in 1987.

Erna Lehan, director of the College Food Service, opened the doors to a new College Union Dining Hall on the Lake Merced campus in September 1953. This large, modern building, leased to the Associated Students, housed a main dining room where this senior breakfast was held in 1957.

The Gator Swamp served as the recreation and meeting center, where students could play cards or ping-pong or join a sing-along while someone played the red piano. Open from 9:00 a.m. to 3:00 p.m., the center was situated south of the Student Union and was under the direction of students in Prof. Helen "Polly" Glyer's recreational leadership class.

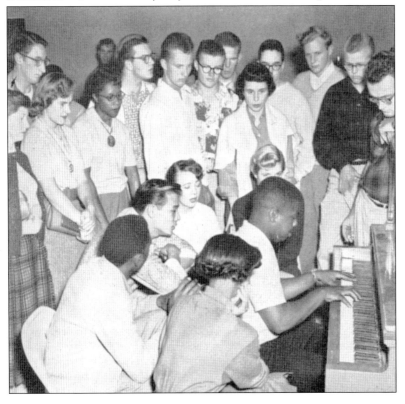

Students gather around the red piano in the Gator Swamp to sing songs and socialize. Professor Glyer was regarded as a teacher of unusual excellence in the Division of Health, Physical Education, and Recreation. Her recreation administration students completed long-term plans to improve recreational facilities in the community.

After World War II, San Francisco State attracted an older student demographic. During the 1950s, some of the Gator football squad members were service veterans, and several were married. Bob Rodrigo (left, junior fullback) and Wayne Taylor (right, All-State halfback) are shown with their wives and children. (Courtesy Sam Goldman.)

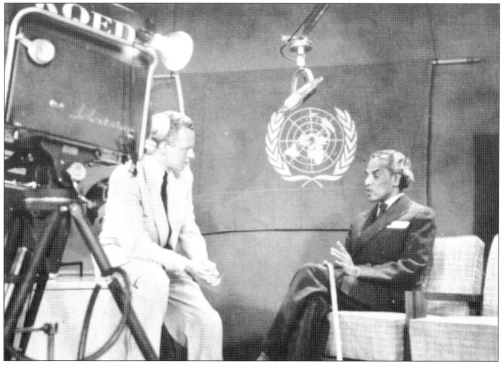

Faculty such as Tom Lantos (currently congressman, California 12th District) worked with local broadcast stations to extend the classroom into the new area of television. In conjunction with KQED (PBS), San Francisco State began an experimental study of educational television to determine if that medium could remedy the overcrowded classroom in 1956.

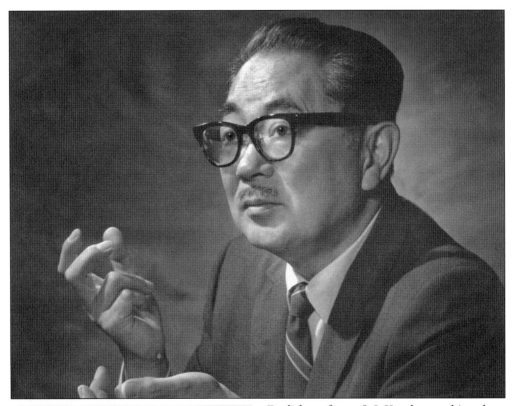

English professor S. I. Hayakawa achieved international renown as a semanticist before coming to San Francisco. Like founding President Burk, Hayakawa was born in Canada. His book *Language in Action* (1941) made him an authority on semantics, the study of meaning in language. When he began teaching at San Francisco State in 1955, he became a leading figure in the Language Arts Division.

Creative writing professor Walter Van Tilberg Clark received worldwide attention for his books *The Track of the Cat* and *The Oxbow Incident*. As director of the creative writing program from 1956 to 1962, he was one of the most distinguished members of the San Francisco State community. After Clark's death, a memorial fund was established in his name to support the student literary magazines *Transfer* and *Arcade*.

Art professor Evelyn Erickson taught costume, design, and beginning design and color from 1945 until 1968. She ran the Style Service from room 207 in the arts and industries building, offering free counseling on how to dress for success for both male and female students. Advice was given on personal grooming, selecting color and style, assembling and maintaining clothes, and developing imagination in dress.

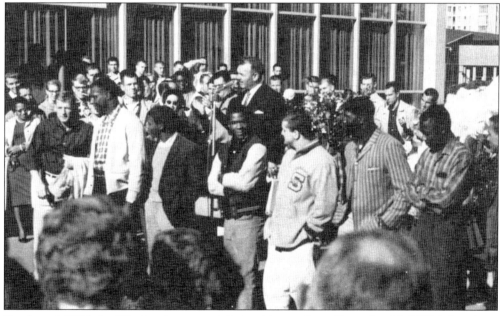

Head coach "Little Joe" Verducci rouses spirit at a victory rally on December 14, 1959. A dormitory was named after Verducci, who was San Francisco State's football coach during the 1950s and 1960s. The college's spirit reflected sensibilities unique to the Bay Area's diverse communities. The Block S Society, fraternities, and sororities incorporated school colors and symbols to convey spirit to rival teams.

Creative arts dean J. Fenton McKenna and drama department chair Jules Irving cofounded Kampus Kapers to showcase student talent in 1945. At age 18, San Francisco State track star Johnny Mathis, pictured in the lower left corner, first performed Richard Vartanian's song "Shadows on My Heart" in a showstopper for Kampus Kapers in 1955.

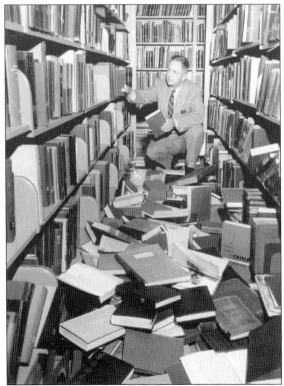

On March 22, 1957, an earthquake centered in Daly City, California, rocked the San Francisco peninsula. The library was hardest hit, with books thrown to the floor and knee deep in some areas. Library director Kenneth Brough went to work sorting and shelving. After the 1906 earthquake and fire, students used the Mechanics Institute Library and the public library to complete assignments when the Normal School's facility was destroyed.

Glenn S. Dumke became the fifth president. He shaped the California Master Plan for Higher Education. The Donahoe Higher Education Act of 1960 subsequently put the report's recommendations into law, forming the California State College System (CSCS). Dumke was appointed CSCS chancellor in 1962. Comprised of 23 campuses, California State University is the largest, most diverse university system in the nation.

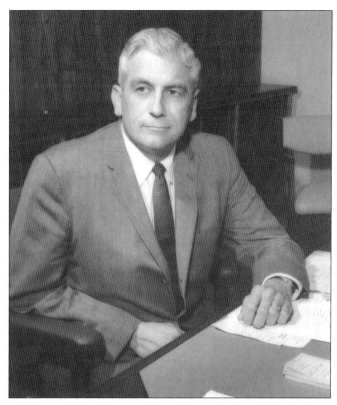

The old science building forms a compass on the eastern boundary of the campus. Exhibiting exotic trees from both the northern and southern hemispheres, East and West, the landscaping around the old science building is now largely connected to curriculum. On June 1, 1958, a greenhouse for botanicals used in teaching was placed on the southwest side of the building.

A lily resides in the campus greenhouse. Botany and nature study were among the earliest subjects taught at San Francisco State. Today two small, raised brick-bordered beds at the entrance of the old science building contain materials from the greenhouse that can take root, including exotic trees, shrubs, and some maritime plants that professors have students identify for class projects. (Photograph by Karen Linsley.)

Pres. Glenn Dumke receives a lei and a kiss from a student as his wife, Dorothy, looks on during a Hawaiian Club dinner. Hui O Aikane was organized to promote friendship and an understanding of the culture of students from Hawaii. The Glenn and Dorothy Dumke Fellowship was established in 1993 to encourage California State University graduate students to study public policy issues.

The Frederic Burk School remained the only training school of its kind in the California State College System. It provided the best education possible for children from kindergarten to sixth grade and gave students the opportunity to observe outstanding teaching methods. The Frederic Burk Elementary School, the campus demonstration facility of the School of Education, was closed by the state on June 30, 1971.

The Downtown Center, located on Nob Hill, was established in September 1958. The center became a hub for coordinating the resources of the college and the community through conferences and an expanded extension program.

The household arts department was divided into sewing and cookery in 1919 and then became household economics in 1921. In 1948, household economics became a separate department in the School of Education. Consumer and family studies began in the School of Education in 1984, expanding and transferring to the College of Health and Human Services when a dietetics program was added.

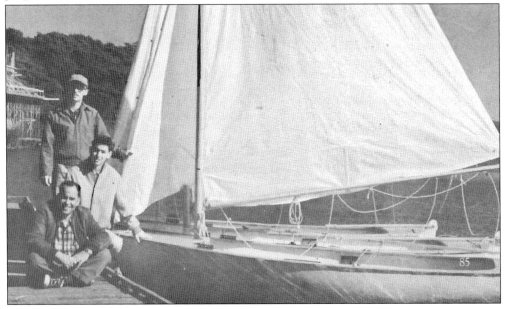

The Sailing Club's three boats, the *Peril*, *Panic*, and *Perish*, were frequently seen on Lake Merced on the weekends. San Francisco State competed with the University of California–Berkeley in a series of intercollegiate regattas in the early 1960s.

Originally known as the College or Student Union, the Commons was completed in October 1953. The TUB, with its jukebox, had everything from hot spaghetti to cold soda served from food vending machines while an addition was built in 1962. Student Daniel Nordquist won the campus-wide contest to name the new gathering spot with his submission of "the TUB" (Temporary Union Building).

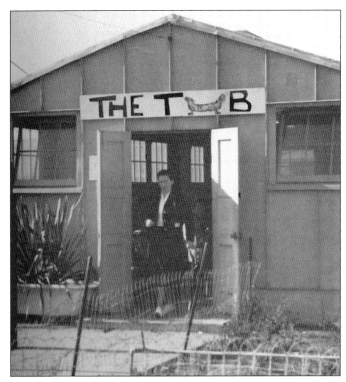

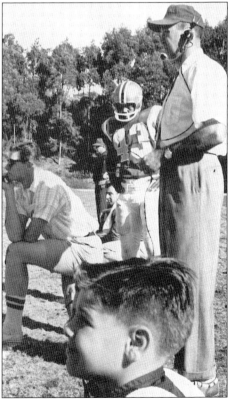

Coach Vic Rowen (standing, right) was an innovator of the passing game in football. Many successful coaches in professional and college football were influenced by the concepts developed by Rowen during his San Francisco State tenure. With his guidance, the Gators won eight Far Western Conference titles between 1954 and 1967.

Many friendships were forged in the Gator locker room. Athletic director Joe Verducci solidified the success of San Francisco State's athletic programs by gaining community support and building campus spirit. The 1955 Gator football squad was known for its "pony backfield" consisting of fast and agile runners.

Three

COUNTERCULTURE EVOLUTION, EDUCATIONAL REVOLUTION 1960–1969

Paul Dodd became sixth president in 1962 following Frank L. Fenton's brief term as acting president. Dodd would lead the college in erecting the first campus-sponsored free speech platform in the country. San Francisco State, known for its community-based curriculum, owes this legacy to the establishment of the Experimental College in 1965. Experimental College leaders felt students should take responsibility for their own education and that learning could start anywhere as long as students cared about the problems being tackled. Like early educational philosophies fostered at San Francisco State related to individualized instruction, the Experimental College encouraged self-directed instruction with a mandate of relevancy. However, its connection to Bay Area counterculture movements made it a volatile environment conducive for educational innovation. Supported by students, faculty, and acting president Stanley Paulson, the Experimental College pioneered a student-initiated curriculum later adopted in other California State Colleges. Students overwhelmingly responded to courses offered through the Experimental College, driving its growth. By late 1967, Experimental College enrollment had grown to 2,000—about 15 percent of San Francisco State's total enrollment.

In 1966, San Francisco State students Sharon Martinas and Donna Mikkelson started the Community Services Institute (CSI), designed to develop work-studies in urban communities through the Experimental College. CSI provided the means for college students, faculty, and administrators to partner with various local community organizations to find grassroots solutions for social problems. Students were also able to earn academic credit for community work: "This area of the Experimental College is an attempt to find a third and more creative alternative based on a few basic assumptions: that students can learn most about communities by making them the environment of learning; that knowledge can and aught to be gathered in response to needs of people actually living in communities and desiring to actively influence and control the decisions that direct their lives; that teaching and learning are mutual processes."

Another San Francisco State student, Roger Alvarado, established the Tutorial Program in which students provided one-on-one tutoring to children in the Mission District. The Black Students Union (BSU) questioned the educational validity of white students tutoring black children and argued that it was necessary for a black tutor to teach a black child in order to develop that child's sense of racial pride.

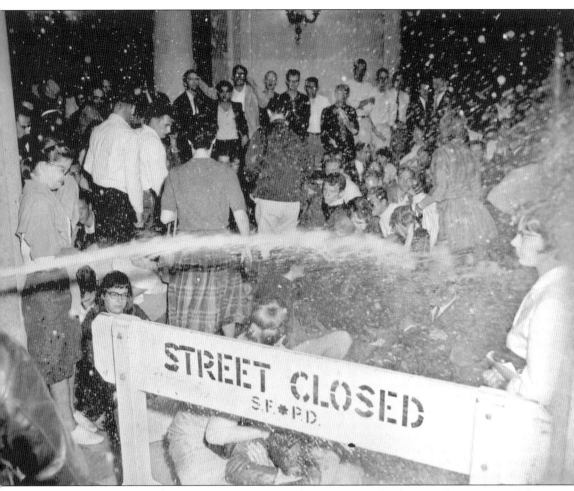

On Friday, May 13, 1960, San Francisco State students were involved in a violent protest of the House Committee on Un-American Activities hearings held at San Francisco City Hall. The incident culminated in an altercation on the marble steps, where police used high-pressure fire hoses to force protestors back. In the end, 64 demonstrators were arrested and 12 were hospitalized with injuries. (Courtesy *San Francisco Chronicle*.)

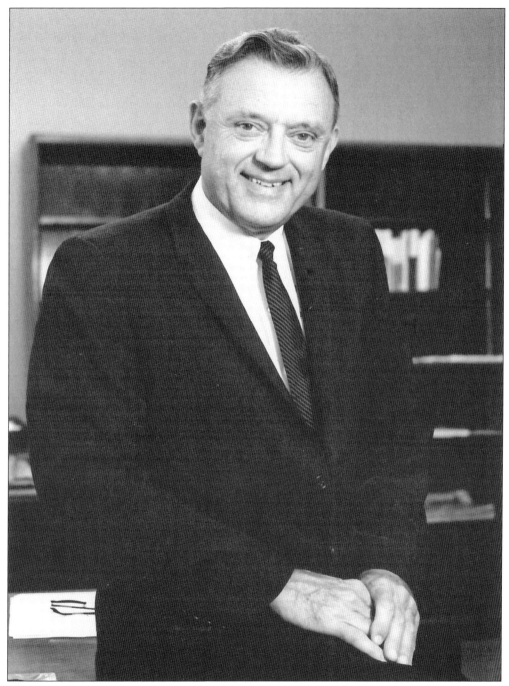

Glenn Dumke was appointed chancellor of the California State College System, and Dr. Paul Dodd became president of San Francisco State in 1962. Dodd was an expert in economics, industrial relations, and educational administration. Before his appointment, he worked a special assignment as a consultant for the Middle East Technical University in Aukara, Turkey.

Students prepared to travel abroad in 1960 as part of People to People, a national program initiated by Pres. Dwight D. Eisenhower in 1956 and sponsored on campus by International Student Affairs. San Francisco State in turn developed Friend to Friend to acquaint international and out-of-state students to campus life. One campus dormitory was dedicated in honor of former dean of women Mary Ward (1886–1957) the same year.

Kampus Kapers '61, performed in the main auditorium, was another hit with an old car and new acts. San Francisco State students had obtained a parade license from city hall to promote *Kampus Kapers '58*. Local television stations covered the three-block-long parade from lower Market Street to the campus on the 5:00 news and the *Don Sherwood Show*.

The College of Science and Engineering, pictured before the addition of the greenhouse, can be traced back to 1899, when neurology, physiology, general biology, and nature study were introduced for teacher training. Anatomy was taught in 1941. The astronomy department was established in 1940. Bacteriology was first taught in 1940 and microbiology in 1964. Today the college continues its mission of research and teaching, training students for industry and graduate programs.

San Francisco State creative arts alumni entered careers in the growing Bay Area entertainment industry. Here broadcasting professor Herb Zettl (seated) works with remote television equipment backstage in the main auditorium (later named Knuth Hall) in the fall of 1961.

The on-campus Gatorville Association accommodated the married student community living in the converted army barracks formerly known as Vet's Village. Students residing at Gatorville attended San Francisco State and worked part-time or full-time jobs. The complex was demolished in 1975 after becoming rundown.

San Francisco State has come a long way from its white-clad female students reverently stepping in careful formations during the Ritual of the Teachers' Guild Service performed during the 1910s and 1920s. Here Delta Gamma Tau and Bib 'N' Tucker "mix it up" at a Toga Ball in 1961.

In 1963, California State College chancellor Dumke boasted to students, "San Francisco State is a big college—one of the largest in the nation. But, more important, it is a GOOD college, with an excellent faculty and a broad and well-organized instructional program. . . . All of these things have been provided by the State of California for one purpose—to serve the students who attend here."

Snowmen mysteriously appeared on the Quad in front of the college library, and the Commons took on the appearance of a ski lodge after a rare snowfall on January 21, 1962.

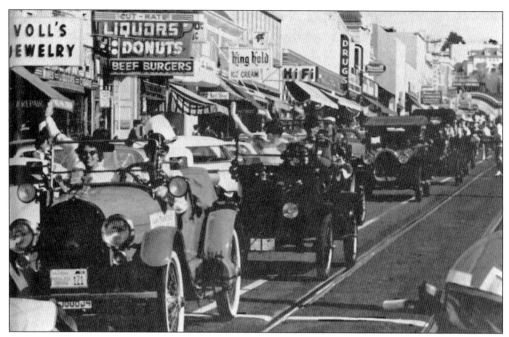

The 1962 homecoming game was preceded by a parade featuring 11 floats sponsored by sororities, fraternities, and other campus organizations. Assembling at Market and Drumm Streets, floats with the theme "Hey, Look Me Over" stopped traffic as they made their way over Twin Peaks and through Stonestown before reaching campus.

The San Francisco State campus is usually shrouded in fog throughout the summer. The months of September and October are traditionally sunny and warm. The Gators defeated Sacramento State 28-7 before 3,000 fogbound fans in Cox Stadium in 1962.

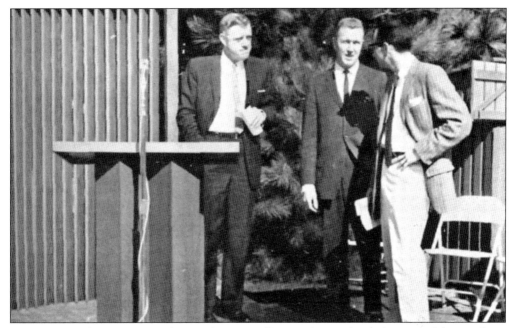

President Dodd, Henry McGuckin, and H. Jay Folberg gather at the dedication of the speaker's platform on October 15, 1962. Associated Students president Folberg and Campus Speakers Committee chairman Lloyd Crisp led a fight to create a free speech platform at San Francisco State. The Forensics Union, Associated Students, and the speech department appealed to Pres. Paul A. Dodd to erect a speaker's platform.

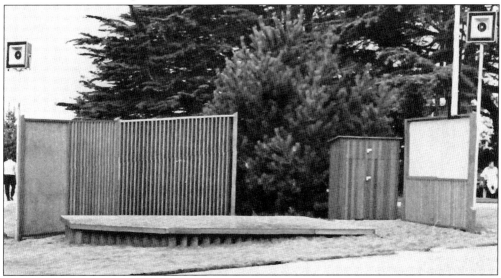

San Francisco State had the first college-sanctioned platform for free speech in the country. Humble in appearance, but monumental in significance, this redwood structure consisted of a windbreak, bulletin boards, a podium, and sound equipment and was located in the northwest corner of the Quad. During the San Francisco State College strike, President Hayakawa declared a state of emergency, banning rallies and the use of sound equipment from December 2, 1968, until April 11, 1969, when the speaker's platform once again served as a center for debates and rallies until being dismantled in 1972.

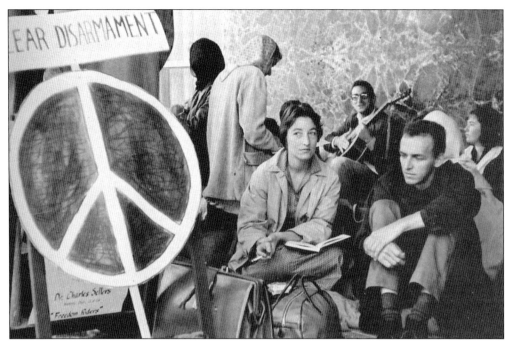

Students held an all-night vigil for nuclear disarmament in the fall of 1961. The same year, faculty and students formulated a Philosophy Statement on Student Activities, stating that students should have all the rights and responsibilities of adults and citizens to participate in university and community affairs. The issues raised in this document became underlying tenets for the University of California–Berkeley's Free Speech Movement.

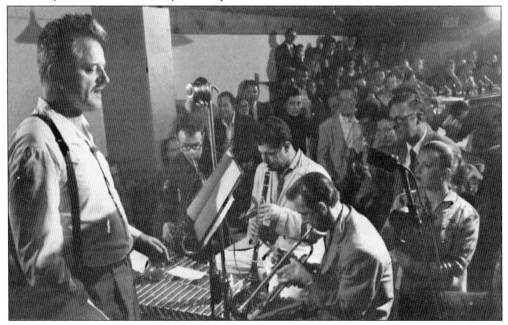

Lecturer Kenneth Rexroth reads at a poetry and jazz session in 1962. While San Francisco State had been at the Lake Merced location for almost a decade, some faculty members still resided in the lower Haight Street neighborhood and participated in its community of artists and poets.

The college has been considered a commuter campus ever since students commuted by ferry to Oakland to attend classes after the 1906 earthquake and fire destroyed the original Powell Street campus. During the early 1960s, when the Municipal Transportation Agency's M car was the only public transit running to San Francisco State, 81 percent of students drove to school, a higher figure than any other college or university in the area.

Two students dissect a frog in the old science building, constructed in 1953 as a state-of-the-art facility. Two new science buildings were completed in the early 1970s and named after the first deans of the Division of Natural Sciences: Robert Thornton (1965–1968) and Jack Hensill (1968–1975). Robert Thorton, a distinguished physicist who worked on theoretical physics problems with Albert Einstein, was the first African American professor at San Francisco State to become a dean.

Students enjoyed impromptu folk music on the Quad when the weather permitted. Dan Hicks (not pictured) entered San Francisco State in 1959 as a broadcasting major. He took up the guitar and became part of San Francisco's folk music scene, performing gigs in local clubs before joining the Charlatans in 1965. (Courtesy SFSU Archives.)

John Handy became the jazz soul of San Francisco State when he introduced jazz as a creative medium in concerts in the Gallery Lounge. Handy, who started playing alto saxophone in 1949, garnered his reputation in jazz with his adventurous style and ease at hitting high notes far beyond his instrument's normal register.

Student Louise Ow Ling performs a ribbon dance during International Week, October 28 through November 3, 1963. Historically, Asian Americans comprised the largest minority group at San Francisco State. (Courtesy SFSU Archives.)

President Dodd and John Butler (pointing at the blueprints) discussed an expansion for the humanities building in 1963. Grounds supervisor Earl Husted started planting a dahlia garden in 1954 and developed hundreds of hybrid dahlias (shown in the background). San Francisco State soon became home to one of the best dahlia beds in the world, consisting of over 2,000 varieties. Husted's most valuable flowers were transplanted to other parts of the campus when the garden was removed in September 1964.

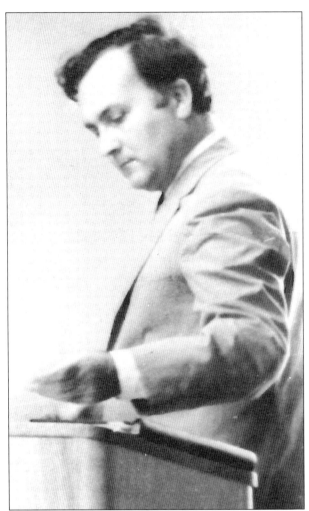

A local poet and assistant director of the Poetry Center, Robert Duncan reads his poetry in the Gallery Lounge on December 10, 1963. Duncan, a lecturer in creative writing, received the Union League Civic Arts Foundation Prize in 1957 and a Guggenheim Fellowship for the year 1963–1964.

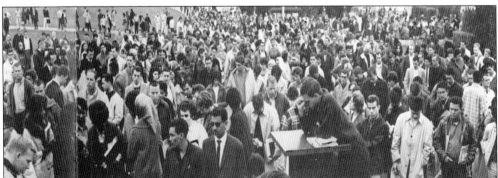

San Francisco State students responded with tears and bewilderment to news of Pres. John F. Kennedy's death on November 22, 1963. As the Commons and classrooms emptied, a throng gathered around the speaker's platform to listen to news of the tragedy broadcasted over transistor radios. Sounds of weeping could be heard above the muffled silence. Many huddled silently; others "just stood, pale and expressionless, knees trembling," according to the *Golden Gater* (November 26, 1963).

Today San Francisco State is considered a national leader in community service learning, a teaching method that melds academic study with community service experiences. Established in 1963, the Associated Students Tutorial Program operated off-campus centers where students taught children literacy in low-income neighborhoods. Tutors volunteered in 12 San Francisco centers, and the program had grown to 325 volunteer teachers by the fall of 1965.

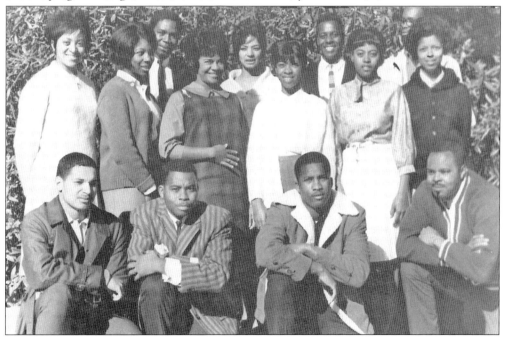

The Negro Student Association formed at San Francisco State in 1963. The Associated Students, interested in supporting civil rights causes, proposed funding 10 students to travel to the South to teach in "freedom schools" for the Student Nonviolent Coordinating Committee (SNCC), but California State College chancellor Dumke asserted that this violated Title 5 of the State Education Code.

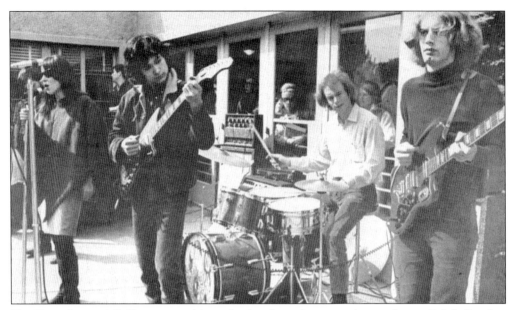

The Experimental College tapped into the local music scene. Art professor Ralph Putzker experimented with light show technology, and Jack Fronk organized a rock 'n' roll workshop. Fronk explained the course explored how to "intensify and synthesize the technical and artistic resources of Rock 'n' Roll, sound and light, drama, poetry, and electric sound production, in which all events are expressed and developed through the joyful dance medium." (Courtesy *Daily Gater*, September 22, 1966.)

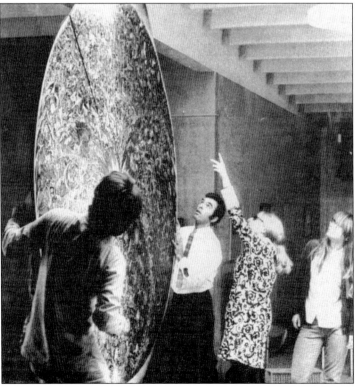

The Associated Students rented a painting called *Evolution* by artist Dion Wright in the fall of 1966. The floor-to-ceiling painting, depicting the evolutionary process, became a backdrop for events occurring in the Gallery Lounge in the months that followed. (Courtesy *Daily Gater*, October 19, 1966.)

Stewart Brand (creator of the *Whole Earth Catalog*), donning face paint in the style of *Evolution*, organized the "Whatever It Is . . ." weekend on the San Francisco State campus from September 30 to October 2, 1966. Event coordinators hoped to expose students to a variety of counterculture experiences on campus. Budgeting thousands of dollars, the weekend garnered the biggest profit of any Associated Students endeavor to date. (Courtesy *Daily Gater*, September 30, 1966.)

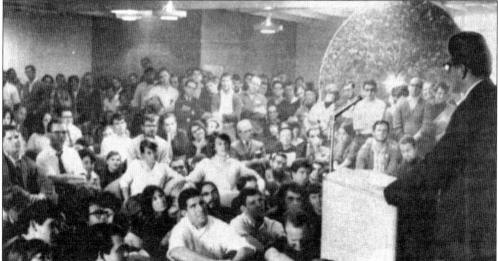

During November 1966, clerks at the Psychedelic Shop and City Lights Bookstore were arrested for selling Lenore Kandel's controversial work "The Love Book" because it was considered obscene. English professor James Scheville, director of the Poetry Center, read "The Love Book" before a crowd in the Gallery Lounge on November 23, 1966. A week later, San Francisco State faculty discussed the nature of literature on KQED. (Courtesy *Daily Gater*, November 29, 1966.)

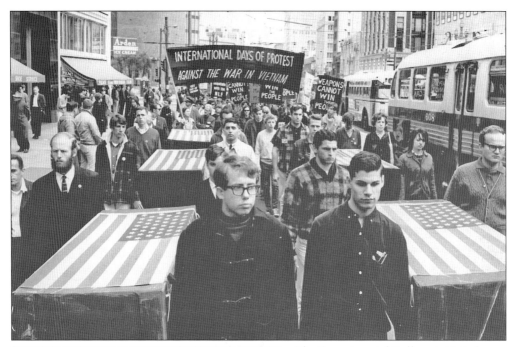

The Experimental College initiated Draft Help to provide accurate information on the whole range of situations and alternatives facing those eligible for the draft. Draft Help staff answered questions on volunteering for the army, deferring enrollment, immigrating to Canada, and how to conscientiously object to the Vietnam War.

Students desiring a new student union building hired architect Moishe Safdie to develop a design for an 11-story building in 1967. Safdie's design sought to direct campus foot traffic through the structure as if it were a bazaar. Safdie wanted students to explore dining and meeting spaces to encourage dynamic use of the building. Despite the positive student response, CSCS trustees rejected the proposal. (Courtesy *Daily Gater*, November 19–20, 1968.)

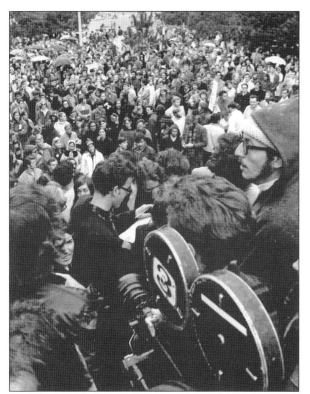

San Francisco State first offered a black studies curriculum under the auspices of the General Education Elective Program in the spring of 1966. The Black Students Union (BSU) established the Black Arts and Culture Series as part of the Experimental College. This series presented a positive focus on the African American experience, and its curriculum included history, law, psychology, humanities, political science, and dance. When BSU and Experimental College leadership disagreed over priorities, the BSU moved to create an autonomous structure.

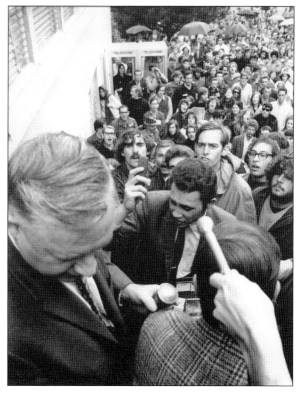

Third World students, comprised of San Francisco's ethnic minorities of African, Asian, and Latin-American desecnt, sought their own school offering interdisciplinary programs relevant to underrepresented groups on campus. At noon on November 6, 1968, Students for a Democratic Society and the Experimental College gathered in front of the Commons in the drizzling rain. White students diverted the media as members of the Third World Liberation Front entered assigned buildings to disrupt classes.

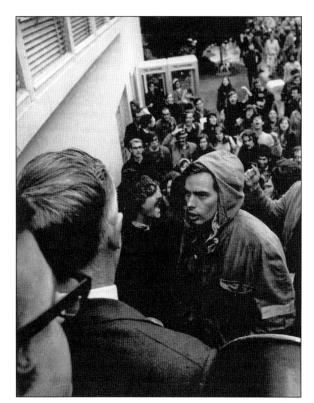

Broadcast and print news media played a major role in shaping the escalating events at San Francisco State related to the strike. Coverage of the disruption to campus life lingered in the memories of government officials and trustees of the California State College system for decades and led both the state and federal government to examine causes for campus unrest.

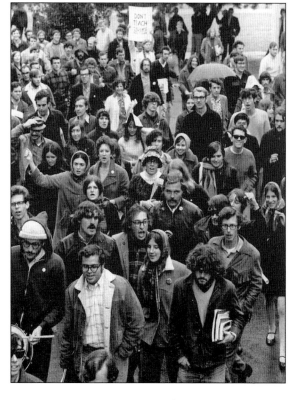

Members of the campus community remember that demonstrations during the San Francisco State strike of 1968–1969 occurred before 3:00 p.m. Reporters gathered images of the protests and then returned to television stations and news bureaus to file reports. While violent protests with police on horseback occurred on the Quad, students simultaneously could be found quietly studying in the college library.

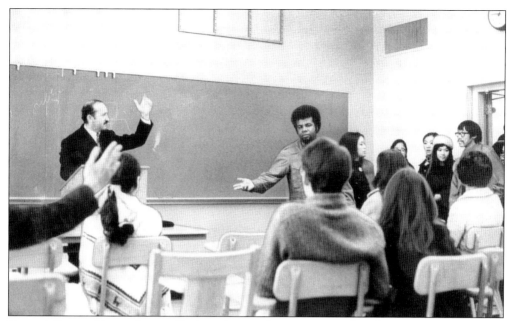

Meanwhile, as white students rallied on the Quad on November 6, 1968, there was a knock on the door in room 304 of the humanities building. An African American student, followed by six Asian and Mexican American members of the Third World Liberation Front, entered a Spanish class, asking, "Why are you holding class? Why aren't you honoring the strike?" (Photograph by Vincent Maggiora; courtesy *San Francisco Chronicle*.)

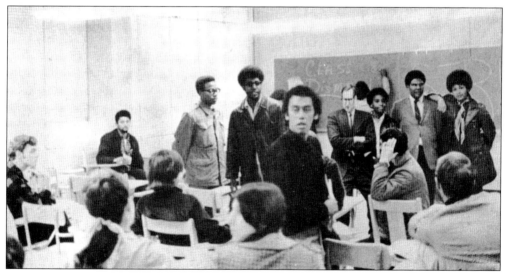

Black studies professor Nathan Hare and members of the BSU shut down another class shortly before 2:00 p.m. and President Hayakawa called in the San Francisco Police Department's tactical squad assembled on the corner of Holloway and Varela. Hare is flanked by Sharon Jones (left) and Gloria Tyus (right). The small campus police force proved to be inadequate to deal with these confrontations. (Courtesy *Phoenix*, November 7, 1968.)

Students consulted bulletin boards near the Commons to get news. Robert L. Tognoli (who later studied photography and anthropology at San Francisco State), a 17-year-old San Carlos High School student, captured this image of San Francisco State at a crossroads. The five-month student and faculty strike became a seminal event in shaping higher education across the country. (Courtesy Robert L. Tognoli.)

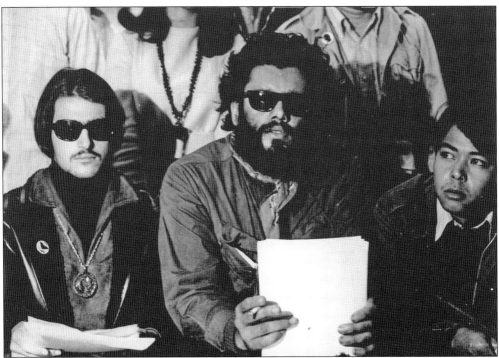

Third World Liberation Front leader Roger Alvarado (center) challenged President Smith's ability to negotiate in good faith even as Smith tendered his resignation on November 26, 1968.

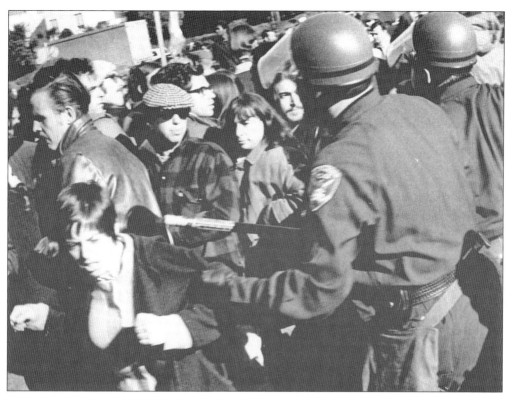

Their clubs drawn, police officers push a crowd of people. Sharon Martinas, among the group (center), became involved with providing legal defense of striking students. The grassroots organizing that had been a hallmark of her work with the Community Services Institute was used to forge powerful alliances amongst strikers and supporters in the community. San Francisco Police came onto campus for the first time, but protestors rejected the tactical squad, demanding, "Police off campus."

San Francisco State faculty polarized during the strike. Presidents Summerskill and Smith were reluctant to call off-campus police during the unrest, but Pres. S. I. Hayakawa, who held strong views on controlling and continuing the business of education, notified police whenever it was necessary to quell disorder.

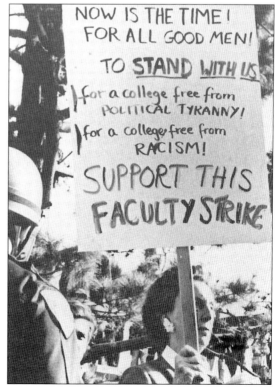

NOW IS THE TIME! FOR ALL GOOD MEN! TO STAND WITH US for a college free from POLITICAL TYRANNY! for a college free from RACISM! SUPPORT THIS FACULTY STRIKE

In a seminal moment, President Hayakawa pulled the plug on the strikers' sound truck on December 5, 1968. When the strike ended after 133 days on March 20, 1969, the college established the first School of Ethnic Studies in the country. (Courtesy *Golden Gater*, December 5, 1968.)

Gloria Tyus, nominated by the BSU, became the first African American homecoming queen at San Francisco State. (Courtesy *Golden Gater*, November 19, 1968.)

Four

EXPERIENCE TEACHES
LOVE IS STRONGER
1970–2007

During the year 1969, new departments were created, reflecting changes and emerging approaches to education. The college created American Indian studies in 1969, along with black studies and La Raza studies. S. I. Hayakawa was named ninth president in 1970; Asian American studies was established the same year.

The San Francisco State strike paved the way for inclusion as new interpretations of academic freedom emerged. Prof. Bea Bain first taught a course entitled Women in the World in 1968, and by 1970, an advisory committee on women's studies had formed. Some early courses offered included Women in Culture Change, Women: Their Search for Identity, Women in Literature, the Psychology of Women, and Women as a Social Force. The bachelor of art in woman studies (later called women studies) was implemented in 1976.

The Gay Liberation Front was created in March 1970 with 30 members (one-third women), but San Francisco State did not recognize it as a legal campus organization. Early organizers Charles Thorp and Betty Kaplowitz advocated developing a gay studies program. On June 1, 1972, San Francisco State College became San Francisco State University. Remnants of the Experimental College ceased to exist when President Hayakawa demolished the speaker's platform, the offices of student organizations, and the Commons in early 1973. Hayakawa would retire to wage a successful campaign for the U.S. Senate. Paul F. Romberg, becoming 10th president in 1973, established the Romberg Tiburon Center for Environmental Studies in Marin County, which offered interdisciplinary instruction in marine and environmental studies. The Gay Liberation Front was recognized as an official campus organization the same year.

The first ethnic survey of students, conducted in the fall of 1973, reflected the contemporary semantics of race and the diversity of the student population. About 15,700 students (74 percent) responded to the survey: 186 (1.2 percent) American Indian, 1,039 (6.6 percent) African American, 390 (2.5 percent) Latin American, 2,294 (14.6 percent) Asian American, 416 (2.7 percent) Pacific Islander, 10,504 (66.9 percent) Caucasian, and 532 (3.4 percent) representing all other groups.

In 1978, faculty and staff collaborated in creating the Shakespeare Garden, which allowed classes to learn about the plants mentioned in Shakespearean works. Also established was the innovative NEXA program melding the humanities and science. In 1979, the Division of Continuing Education worked with the City College of San Francisco to offer classes downtown, establishing the first such state-city venture in California.

Over the years, commencement has been held in different San Francisco locations, including the Scottish Rite Auditorium, the High School of Commerce, Everett Middle School, Roosevelt Middle School, Mission High School, War Memorial Opera House, and San Francisco Civic Auditorium. The last commencement ceremony at the Cow Palace was held on June 1, 1972. Since then, Cox Stadium has been home to San Francisco State graduation ceremonies.

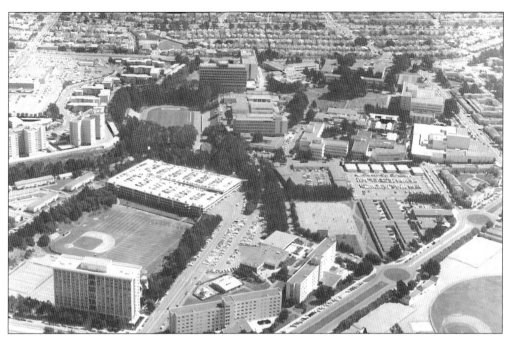

This aerial view of San Francisco State shows how much the campus had grown by 1972. Verducci Hall stands tall in the foreground. With 15,000 full-time-equivalent students, enrollment had passed four times the original amount expected to attend the college. The Stoneson brothers' Stonestown shopping center is pictured in the upper left, and the Parkmerced community is on the right.

Student Richard Oakes, a Mohawk Indian, helped create one of the first American Indian studies programs in the country. In a grassroots effort, Oakes encouraged Native Americans to enroll and worked to develop the program's initial curriculum. In the fall of 1969, Richard Oakes led the San Francisco State contingent in the 19-month-long Native American occupation of Alcatraz. The occupation sought to turn Alcatraz into a center for Native American studies, to form a spiritual center, and to establish a center for ecological work to fight pollution.

Students gather in front of the Commons during more peaceful days in 1962. The Huts and bookstore are in the background. In lieu of paying rent for office space, student groups contributed to a college union fund. Many original images of student activities from the 1960s were destroyed when President Hayakawa ordered offices in the Huts to be padlocked and then had them bulldozed over winter break in order to curtail student activism and make way for the new student union.

Students left the campus quiet after completing final exams in December 1972. That January, President Hayakawa unceremoniously threw a rock through a window of the Commons, which had been a gathering spot for students during turbulent times. The Commons was just another controversial symbol to be demolished. Students returned for spring semester to find the speaker's platform, the Commons, and the Huts gone.

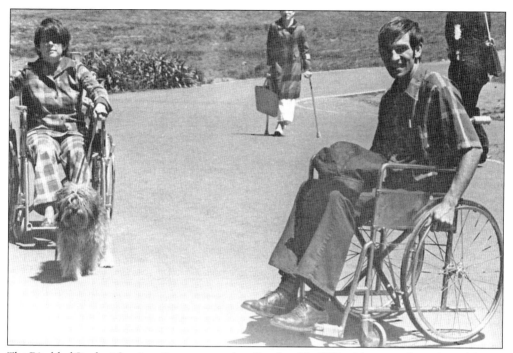

The Disabled Student Services Center opened on October 20, 1975, with a grant from the California Department of Rehabilitation. The center was created because Disabled Student Union members wanted an office on campus to support independence and integration. San Francisco State had the first such center in the California State University System.

The Student Union has been a focal point of the Lake Merced campus since 1975. Architect Pafford Keatinge Clay dramatically altered San Francisco State's landscape with his bipyramidical design for a student union. Clay explained his philosophy of the "Pyramid of Silence and the Pyramid of Sound" in July 1975, asserting that the Union was created "to solve the special physical and emotional needs of this rich and unique community."

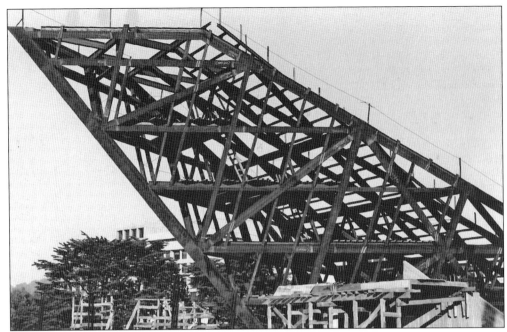

Construction of the $8-million 137,000-square-foot Student Union building started in 1973. Student unions were first established in British universities as debating societies, and events at San Francisco State's Student Union continue this tradition of exploring issues. Pafford Keatinge Clay explained, "Painting, sculpture, engineering and landscaping are not separate but form one spatial experience, for want of a better name: architecture, a place for exploration."

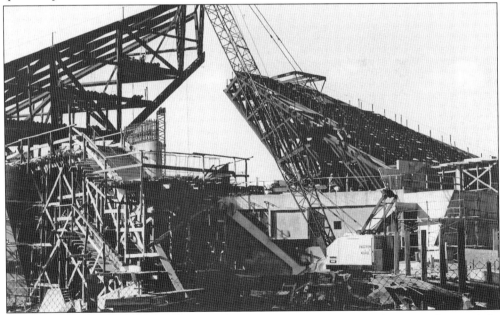

With its complex architecture, the Student Union was designed to complement and extend the learning process of the classroom. Clay created an unusual space that functions as a focus for Associated Students activities. The multilevel structure—including lounges, offices, restaurants, study areas, a bookstore, and a gift shop—replaced the Commons.

Clay set out to understand San Francisco State by interacting with students as individuals and students in groups so that his design would embody the moods and mystiques of the community it would serve over the building's projected 40-year lifespan. On clear days, the views from atop the pyramid on the Student Union are breathtaking even with a brisk wind. From some angles, the pyramids look like ships passing. (Photograph by Thomas Levy.)

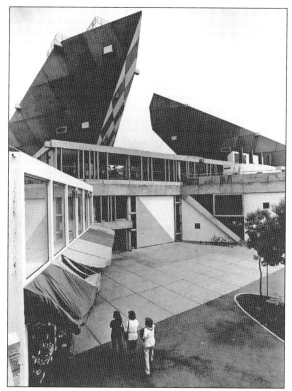

"Once a Con" (shot in November 1976 and aired on March 3, 1977), episode 113 of the popular ABC television series *The Streets of San Francisco*, used the Student Union as a backdrop. The story line, which involved a female student being murdered after exiting a bus on Holloway Avenue, created a debate on campus about media depictions of women.

The crossroads of the university is captured in this 180-degree fish-eye view of the Quad captures the two new science buildings in the upper left and the new addition to the J. Paul Leonard Library in the upper right. The future Memorial Grove appears to the far left, taken from the north tower of the Student Union. Clay's design for the Student Union created a striking visual landmark that speaks of the new directions emerging out of dynamic discourse while the earnest work of teaching never ceases.

While their parents are in class, children at Lilliput childcare center explore the campus gardens. San Francisco State's childcare center started in the late 1940s, its pink nursery walls decorated with children's artwork. In 1970, the Associated Students childcare center, Lilliput, was opened as a cooperative adjacent to the dining center. The Marion Wright Edelman Institute for the Study of Children, Youth, and Families was established in 1995 to examine issues of child development.

Located within one of the world's most beautiful cities, San Francisco State maintains a park-like quality. The City of San Francisco presented the college with a statue of St. Francis by Benjamin Bufano in 1965. Today the red-granite St. Francis statue peeks out from under a rhododendron in the Quad, quietly blessing all who pass.

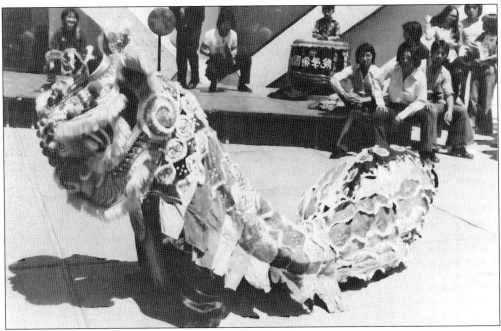

The dragon dance, performed during the annual Spring Carnival in 1976, evolved from a ritual rain dance that was popular during Chinese New Year. Asian Americans (statistically encompassing Chinese, Japanese, and Korean Americans) have historically been the largest minority group at San Francisco State, comprising 12.5 percent of degree recipients in 1976.

Students remain civically engaged by volunteering in new ways. The Associated Students Community Involvement Program (CIP), established in 1965, expanded the work of the Tutorial Program by training participants to cultivate organizational skills, social commitment, and political agency. All CIP staff and volunteers attended a seminar in community organizing during which off-campus organizing was assigned as part of their coursework.

Art department students learn about textiles by weaving their own cloth. The college of creative arts has long produced skilled textile artisans who built successful enterprises in the Bay Area. First established as industrial arts in 1925, the design and industry department developed into manual arts in 1928, expanded to industrial arts and design in 1942, and became a department in 1969.

Paul F. Romberg, a specialist in botany and genetics, was appointed president in 1973. Landmarks of his tenure include the construction of a two-building science complex, the establishment of a long-range planning commission that produced a 10-year plan for the university, and the expanded recognition of San Francisco State as an urban university. The Romberg Tiburon Center continues to serve as a multidisciplinary instructional and research facility for the study of the San Francisco Bay and the central California coast.

For one week in July 1980, young violinists and their families from all over the United States and Canada converged at San Francisco State for the fifth American Suzuki Institute West. Violinist Dr. Shin'ichi Suzuki developed an early education method for teaching music to children of five to six years of age.

Students participating in the American Suzuki Institute West take a break and examine the reproduction of a historic virginal in the Frank V. de Bellis Collection in the J. Paul Leonard Library. This collection of Italian cultural materials was donated to California State University in 1964.

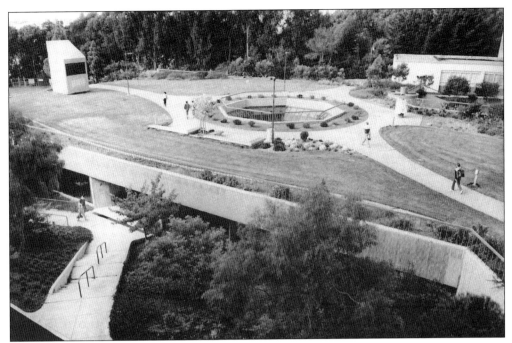

The Student Health Center, the only underground structure at San Francisco State, was completed in 1977. Its underground atrium center remains visible from above at the intersection of three paths. Designed by architect William Valentine (designer of Moscone Center in San Francisco), the Student Health Center has been landscaped to be a welcoming entryway from the parking structure. (Photograph by Jeff Lockhart.)

Biology professor Bernie Goldstein (class of 1962) remains an important part of the campus community. In 1969, he drew hundreds of students to his new Human Sexuality course, which had to be conducted in McKenna Theater because of its large enrollment. The human sexuality studies department was established in 1981.

A media information assistant for Extended Education, Jon Christensen (class of 1985) takes a turn staffing San Francisco State's booth at the San Francisco Fair and Exposition held at Moscone Center from July 27 to 31, 1983. Thousands of attendees paused to look at the exhibit of famous San Francisco State alumni, including Willie Brown (class of 1955), Joanie Greggains (class of 1971), George Fenneman (class of 1941), and Bill Honig (class of 1972). (Photograph by Janet Wade.)

Jack Adams, assistant director of the Student Union, looks on as provost Larry Ianni serves a giant submarine sandwich atop the Student Union during Fallfest 1983. In 1993, a hall in the Student Union was renamed Jack Adams Hall in remembrance of the major role he took in improving and enhancing the quality of student life on campus from 1981 to 1992. (Photograph by Paul Miller.)

First taught in the English department, journalism was established as its own department in 1933. San Francisco State student journalists have produced award-winning newspapers dating back to the 1920s. Student newspapers have changed over the years: *Vigilante* (1922–1928), *Bay Leaf* (1928–1931), *Phoenix* (1968–1986), *Zengers* (1971–1977), and the *Golden Gater* (1931–present), continued by the Golden Gate *X-PRESS* Publications online at http://xpress.sfsu.edu. (Photograph by Jeff Lockhart.)

San Francisco State's cable station, Channel 35, first went on the air with student-produced programs in 1981. Broadcasting professor C. R. "Buzz" Anderson (left) taught directing and production to generations of Bay Area broadcasters. Anderson also provided the rich baritone voice behind "Touchtone," directing students through the telephone class registration process instituted by Enrollment Services in 1991. (Photograph by Paul Miller.)

Students huddle under umbrellas during a memorable El Nino year in 1983. Located in a coastal climate, San Francisco State students occasionally have to face fierce elements—rain and wind—as they travel between classes. (Photograph by Paul Miller.)

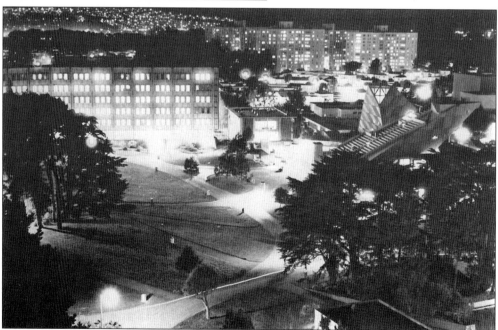

Faculty and students demanded better security and night lighting. Landscape architect David Mayes reshaped and graded the pathway entering the campus and installed Lexan window lighting with underground electrical work. This night view captures the campus's connection to the adjacent Parkmerced neighborhood. (Photograph by Paul Miller.)

Chia-Wei Woo, named 11th president in 1983, became the first Chinese American to head a large university in the United States. Woo, pictured at left with San Francisco mayor Art Agnos, expanded relationships throughout the Pacific Rim and shaped the first branding for San Francisco State, dubbing it "the City's University." Five years later, the Downtown Center relocated to 425 Market Street. His work culminated with a weeklong celebration of the university that included programs and seminars on campus and throughout the city.

A new university logo was introduced in April 1987 to create a visual identity for San Francisco State. Pres. Chia-Wei Woo sought to unite the university's name with the best-known images of the city. The logo design, created by alumnus John Davis, was launched during San Francisco State University Week from October 13 to 18, 1986.

Students in dance professor Nontsizi Cayou's class study the cultures of countries from which the dances come. She started teaching in 1966 and became a catalyst for establishing the dance department in the college of creative arts. Cayou (class of 1962) was instrumental in initiating San Francisco State's undergraduate dance ethnology concentration, one of the first such programs in the country to frame the study of dance within cultural contexts.

Robert A. Corrigan, who became 12th president in 1988, brought to campus his earlier experience developing ethnic studies and women studies programs. President Corrigan sought to develop San Francisco State as a national model for a public urban university. In 1994, he restructured the university's organization from schools to colleges and continues to build lasting relationships in the community.

President Corrigan's first year corresponded with San Francisco State's 90th anniversary celebration, and he used this time to draw alumni back to campus. As the university struggled to accommodate ever-increasing enrollment, Corrigan worked to plan and build more housing on campus. He also aimed to revitalize the physical plant to provide the best educational technology while quietly shaping the campus's aesthetic landscape to commemorate the university's rich past. (Photograph by Yvonne Soy.)

On October 17, 1989, at 5:04 p.m., in the midst of a weeklong celebration of San Francisco State's anniversary, the Loma Prieta earthquake occurred. Classrooms were evacuated. Students, faculty, and staff gathered on the Quad to hear the news on portable radios. Within minutes, San Francisco State's Emergency Operations Center mobilized to respond.

Because of the earthquake, classes were cancelled immediately and did not resume for another week. Residents of Verducci Hall, which sustained the most structural damage, were forced to double up with students in Mary Ward and Mary Park Halls. The J. Paul Leonard Library did not sustain structural damage, but about one-third of its holdings fell from the shelves.

Residents from Verducci Hall gather around an impromptu bonfire in Parking Lot 8. They would be unable to return to their rooms for weeks while contractors made repairs. The earthquake-damaged hall had remained vacant for almost a decade until it was imploded on March 27, 1999, to clear the way for San Francisco State's Village at Centennial Square resident apartment complex.

President Corrigan and his wife, Joyce, served celebration cake to dorm residents early on the evening of October 18, 1989, and the remaining cake was donated to centers serving meals to displaced city residents. In the following days, President Corrigan toured the J. Paul Leonard Library to survey damage and offer moral support to staffers beginning the long process of recovery work.

Engineering professors Ralf Hotchkiss and Peter Phaelzer established the Wheeled Mobility Center in 1989. Hotchkiss pioneered wheelchair designs that could be built in developing countries with local materials. Hotchkiss created an internationally known wheelchair designing and construction course at San Francisco State that is now offered through the College of Extended Learning.

SAN FRANCISCO STATE UNIVERSITY

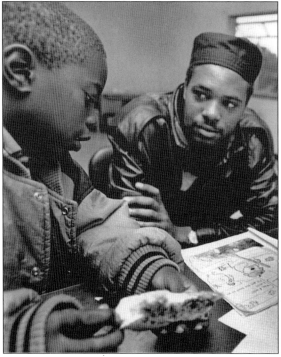

The San Francisco State AIDS Quilt joined more than 14,000 quilt panels in a national tour of the Names Project AIDS Memorial Quilt in the spring of 1991. Cleve Jones, who attended San Francisco State, developed Names Project. The quilt honored 45 members of the San Francisco State community (students, staff, and faculty) who had died from AIDS or ARC. Theater arts professors Bill Jones and Jack Buyers designed the San Francisco State AIDS Quilt to resemble the Memorial Grove, a quiet oasis on campus dedicated on World AIDS Day in 1989.

Algernon Dedmond assists eight-year-old Andre Mitchell with his homework. Reminiscent of the Associated Students Tutorial Program of the mid-1960s, the tutorial program developed by Alpha Phi Omega helps children living in San Francisco's Sunnydale housing project.

In 2000, all disability-related serves were reorganized under the Disabilities Program and Resource Center to address disability access issues related to information technology. Carrying on with the initiative of individualized instruction, San Francisco State continues to work at creating a campus that understands and values the experiences of disability as an aspect of human diversity by providing individual accommodation. (Photograph by Alain McLaughlin.)

Students play soccer in the Quad. At times when some colleges continued to be torn by racial tensions, San Francisco State became one of the country's leading campuses for promoting racial and ethnic diversity in and out of the classroom. Over a century ago, founding president Frederic L. Burk created an electrifying learning atmosphere by introducing individualized instruction. Generations of students have also shaped traditions of inclusion, making San Francisco State stand alone as a preeminent urban university.

American Indian studies instructor Barney Hoehner (right) led his class in a traditional Lakota song while Darlene Maliauaopele trained as a second singer in preparation for the 1999 annual powwow. Powwows have offered the San Francisco State community opportunities to experience the powerful spiritual rhythms created at Native American gatherings. The Student Kouncil of Indian Nations (SKIN) organized the first annual powwow at San Francisco State in 1975. (Photograph by Kathy Strauss.)

The students who attend San Francisco State become part of a continuum of commitment to community service learning and civic engagement. Alumni make a cumulative difference in the world through leadership, creativity, activities in civic affairs, and principled citizenship.

San Francisco State's first commencement was held on June 15, 1901, with 36 young women graduating to enter the field of teaching. Since then, the university has gone beyond its original mission to train teachers and is now associated with outstanding research and scholarly achievement in the sciences, business, health, communications, and the humanities.

INDEX

ACROSS AMERICA, PEOPLE ARE DISCOVERING SOMETHING WONDERFUL. *THEIR HERITAGE.*

Arcadia Publishing is the leading local history publisher in the United States. With more than 3,000 titles in print and hundreds of new titles released every year, Arcadia has extensive specialized experience chronicling the history of communities and celebrating America's hidden stories, bringing to life the people, places, and events from the past. To discover the history of other communities across the nation, please visit:

www.arcadiapublishing.com

Customized search tools allow you to find regional history books about the town where you grew up, the cities where your friends and family live, the town where your parents met, or even that retirement spot you've been dreaming about.